Effects of Arts Education
on
Participation in the Arts

Effects of Arts Education
on
Participation in the Arts

Louis Bergonzi and Julia Smith

Research Division Report #36

National Endowment for the Arts
Seven Locks Press
Santa Ana, California

Effects of Arts Education on Participation in the Arts is Report #36 in a series on matters of interest to the arts community commissioned by the Research Division of the National Endowment for the Arts.

Cover: Dr. Jill Beck teaching Helen Tamiris Joshua to third, fourth, and fifth level students at the School of the Hartford Ballet as part of their dance history curriculum development project.

First printed 1996

Library of Congress Cataloging-in-Publication Data
Bergonzi, Louis, 1957–
 Effects of arts education on participation in the arts / Louis Bergonzi and Julia Smith
 p. cm. — (Research Division report: 36)
 Includes bibliographical references.
 ISBN 0-929765-47-8 (paperback)
 1. Arts—United States—Citizen participation. 2. Arts—Study and teaching–United States. 3. Arts surveys—United States. 4. Arts audiences—United States. I. Smith, Julia, 1962– . II. Title. III. Series: Research Division report (National Endowment for the Arts. Research Division); 36.
 NX230.B47 1996
 700'.70'73—dc20 96-7843
 CIP

Manufactured in the United States of America

Seven Locks Press
Santa Ana, California
1-800-354-5348

Table of Contents

Tables

Figures

Executive Summary

Introduction

The arts education that Americans gain and its potential effect on their participation in the arts is an issue that is central to the development and preservation of our uniquely diverse American culture. Thus it is critical to look very carefully at what kind of education in the arts Americans receive, where they receive it, and what influence it may have on active involvement in the arts later in life. Information regarding the impact of arts education on arts participation is necessary for any individual or organization interested in arts education at any level or in the broader range of educational and cultural policy.

This report identifies broad patterns of arts participation and arts education among the American public and investigates the effects of arts education on arts participation as they apply to all Americans.[1] The focus is on the following questions:

1. Do people become more actively involved in music, dance, writing, acting, and visual arts as a consequence of arts education?
2. How does arts education make a contribution (or reduce the differences) to arts participation among people of different socioeconomic status, gender, racial, and ethnic groups?
3. Do any of the answers to the above questions differ when distinguishing between arts education that is based in K–12 schools and that which is based in the private sector community outside of school?
4. Which is more important to increasing active participation—arts education or general education?

This report uses data from the 1992 Survey of Public Participation in the Arts (SPPA92), which was conducted by the U.S. Census Bureau on behalf of the National Endowment for the Arts, and is to date the most comprehensive indication of arts participation in the United States. Data are representative of the population of the United States with respect to age, race, and gender. Even the most basic analyses reveal important differences in both arts education and arts participation among the racial and ethnic groups considered in the SPPA92: namely, African Americans, Asians, Hispanics, Native Americans, and whites. Therefore, in this report each group is considered separately.[2]

1

Measures

The art forms from the SPPA92 that were used predominantly in these analyses are (depending on the particular variable) classical music, jazz, opera, musical play or operetta, non-musical dramatic play, ballet, other forms of dance, poetry, novels or short stories, visual art, and video programs about the arts or artists. Although the SPPA92 does not include all art forms and types of art in which Americans participate, it does allow consideration of three dimensions of arts participation: attendance, production, and accessing the arts via the media. In this report, participation in the arts activities included in the survey is also considered as either consumptive (attendance and media-accessed arts participation) or productive (performance, creating) in nature. With this distinction, it is important to keep in mind that consumptive participation is not merely passive. Individuals actively "consuming" music, literature, dramatic performances, dance, or visual displays of art use their active perception and critical reasoning skills.

For the purposes of this report, the measures of arts consumption employed were the following: live attendance at arts performances (attendance); listening to radio broadcasts or audio recordings on record, tape, or compact disc (audio media); watching performances on television and/or using a videocassette recorder (VCR) (video media); and reading print literature or listening to recordings of print literature (print media). Additive standardized scales of arts consumption were constructed, which awarded points for the number of times the respondent consumed a particular type of music, drama, dance, or visual art display in the 12 months that preceded the survey.[3] Over 12,500 Americans responded to questions of this type.

As previously stated, arts production is defined as either performing (performance) or creating (creation). Once again, additive scales were constructed, awarding a point for each type created or performed and, for both scales, an additional point if the performance or creation was publicly demonstrated. The sample size for arts production questions was 5,701.

Finally, an arts education index (arts education density) was created to represent both the breadth and depth of arts instruction across a lifetime. One point was assigned for each type of class taken and one point for each time period (elementary, high school, college, or adult years) during which the respondent took classes. On the other hand, scales for school-based and community-based arts education represented only the number of art forms in which the respondent had lessons while of school age (through age 17).

The SPPA92 also requested information about the respondent's back-

ground, including sociodemographic characteristics such as gender, race, and ethnicity. For the purposes of this report, data indicating respondent's family income, parents' level of education, and the number of cars the respondent owned were combined into a standardized measure of socioeconomic status (SES). Respondents also answered questions about their leisure activities (movies, sports, amusement parks, exercise, outdoor activities, volunteer or charity work, home improvement/repair, and gardening) and the number of hours they watched television on an average day. These responses were combined into a standardized measure of leisure activity.

Research Focus

The purpose of this report is not to consider differences in arts participation by race and ethnicity.[4] However, from a perspective of aesthetic and educational egalitarianism, the question is asked: Does arts education make arts participation more accessible to Americans? To answer this question, arts participation as an outcome of arts education was viewed, taking into consideration one's lifestyle. Also explored was the question of whether arts education reduced or possibly eliminated observed gender, ethnic, or socioeconomic status differences in arts participation.

Further, because the SPPA92 questions distinguished between arts education received in school from that received in the community (outside of school), it was possible to compare the effects of these two arts education agencies on arts participation and to pay special attention to the sociodemographic characteristics of those who receive arts education from each. This was done in recognition of the view that public schools emphasize equality of opportunity and are therefore of somewhat different purpose than most arts education programs available through the private sector, which often require financial remuneration from the students or their families.[5]

Findings

Effects of Arts Education on Arts Participation

To summarize the results in different areas more specifically, each outcome has been highlighted with a summary of findings, followed by some general observations concerning patterns of effects.[6]

Arts Attendance

- Men and women are about equally likely to attend a performance of music, opera, drama, dance, or a museum exhibit, once one takes into account social and personal background characteristics and how much time a person has available to attend an arts performance.
- Those who had more arts education were more likely to attend arts performances—a relationship which was about four times stronger than that of any other factor considered.[7]
- More than half the initial differences in attendance associated with SES—one's ability to pay—were removed by considering differences in arts education.
- Maintaining a busier lifestyle reduces one's rate of arts attendance.

Arts Accessed Through Audio Media

- The number of art forms Asians listened to via recordings and broadcasts of music and drama was comparable to whites, whereas African Americans had broader listening habits.
- Arts education was much more important in predicting this type of arts participation than personal background or leisure and more strongly predicts arts listening than any other type of arts participation.
- Higher socioeconomic status led to increased participation via audio media but was only one-third as strong a predictor as arts education.

Arts Accessed Through Video Media

- Of those factors considered in this study, arts education was the only predictor of watching the arts on television or via VCR.
- The variables in these analyses predicted very little of this type of arts participation. Therefore, many of the influences as to why people watch the arts on television remain unexplained.

Arts Accessed Through Print and Print-Related Media

- Women read more than men, even after taking SES and level of arts education into account.
- Asian and Hispanics had less print-media involvement than whites and African Americans, again after taking SES and level of arts education into account.
- Those with higher levels of socioeconomic status also read more.

- Those with more education in the arts read more. This factor was by far the strongest single predictor of time spent reading among the factors considered.

Arts Creation

- Men reported spending much less of their time creating (photography, needlework, painting, musical composition, creative writing) than did women, even after taking arts education, alternate leisure activity level, and SES into account.
- African Americans reported spending less time creating than did other ethnic groups, even after adjusting for the amount of arts education one had.
- Arts education was the strongest predictor of arts creation, reducing the effect of SES substantially.
- Those more active in other pursuits reported less arts creation. In fact, when the amount of leisure activity was also taken into account, SES showed no independent effect on participation in arts creation.

Arts Performance

- African Americans reported spending less time performing than did the other racial/ethnic groups.
- Arts performance was the only type of arts participation that was *not* predicted by arts education despite the probable dominance of arts performance as a goal and instructional practice within arts education.[8]
- Much of the influence of arts performance remains undefined.

Arts education was the strongest predictor of almost all types of arts participation (arts performance being the exception). Those with the most arts education were also the highest consumers and creators of various forms of visual art, music, drama, dance, or literature. Similarly, the higher one's SES, the more one participates in arts activities. On the other hand, at least half of the effect of SES on all types of arts participation was attributable to differences in arts education. Although SES was not as important in increasing participation as was arts education, it did function as a resource factor, contributing to whether or not a person received education in the arts. In addition, of all types of arts participation, listening to the arts via audio media was the most dependent on SES, further revealing socioeconomic status as a restrictive force on arts participation.

School-Based vs. Community-Based Arts Education

As a final exploration into the impact of arts education, consideration was given to the question of how respondents' lessons in the arts taken before the age of 17 in school and in the private sector contribute to arts participation, both separately and together; and to the impact of demographic background of students engaged by each type of arts education agency.

Findings indicate that the higher one's socioeconomic status, the more arts education one received, regardless of where that education was gained, even after adjusting for personal background. It is noteworthy that SES was more important to increased community-based arts education than it was for school-based arts. Whereas men were only slightly less likely than women to take arts courses in school, they were *much* less likely to do so in the community-based arts education agencies outside of school.

After adjusting for socioeconomic status and gender, African Americans, Asians, Hispanics, and whites had about the same level of involvement in arts education in schools. In sharp contrast, white respondents reported much higher levels of community arts education than did Asian, African American, or Hispanic, even after adjusting for socioeconomic status and gender.

Effects on Arts Participation

For almost every type of arts participation, the more one received of both school- and community-based arts education, the more one participated in the arts as an adult, either through consumption or creation.[9] The exception was once again in arts performance, where having received community-based arts education as a child or youth did nothing to predict arts performance, and receiving school-based education actually decreased the likelihood somewhat that individuals would continue to perform as adults.

In sum, a comparison of school-based and community-based arts education does not yield a simple picture as to their relative effects on arts participation. When compared to school-based arts education, receiving arts education that is community-based tends to reflect individuals who were higher in two types of arts participation (attendance and video-media involvement). Although arts education in school contributed to more time spent in arts creation, it appears to slightly *decrease* the likelihood of participation in arts performance. Each type of arts education exerted comparable influence on audio-media involvement. The largest difference between them was in consumption of arts via video media, in which community-based arts education was much more important than school-based arts education.

Effects of General Education vs. Arts Education on Arts Participation

Three sets of analyses for each form of arts participation were conducted to compare the impact on arts participation played by arts education and by the broader socialization context of education.[10] Because individuals' access to these types of education was related to other background features (SES, gender, and ethnicity), an analysis was made of (1) the relationship between arts education and education, (2) the independent effect of each type of education on arts participation after taking the other into account, and (3) the contingent effects of education and arts education; that is, the effect of one depending on how much of the other one received.

(Overall, education is generative—more education in the arts also shows higher levels of general education and vice versa.) Interestingly, differences in school- and community-based arts education primarily occurred between and around the point of high school graduation. High school dropouts reported having received much less school-based arts education than did high school graduates.

Independent Effects of Arts Education and Education on Arts Participation

Generally, more arts education or education (hence, arts/education) meant more arts consumption (attending, listening to, watching, or reading) and more arts creating (writing, composing, drawing, painting). Indeed, arts education had a much stronger impact than did overall educational attainment, even after taking personal background and socioeconomic status into account.

This difference is not surprising, given that general education is by nature less arts-specific. However, there are two remarkable observations. First, although much arts instruction, particularly in the schools, stresses the development of arts performance or production skills, it was arts *consumption* and creation that were more related to arts education, not the more logical arts performance. Arts education (received in either the school or the community) and overall education, once again, did not impact arts performance at all. Second, the effect of education on arts creation does not remain after one considers differences in individuals' level of arts education. However, years of education continued to be a significant factor in predicting Americans' arts consumption habits, even after taking into account the effect of arts education. This result implies that education operates as a socialization force, even if not as directly related to arts participation as arts education.

Interdependency of Arts Education and Overall Education

Because both arts education and general education influenced patterns of arts consumption, whether the patterns themselves were different was explored, as well as whether the effects of overall education and arts education changed depending on how much of the other a person had received. It could be, for example, that getting a solid arts education has a stronger effect on students who have a strong educational background in general, so that arts education simply adds on to the effect of other schooling. On the other hand, it could be the case that arts education is more important for students with less overall education. Put another way, if schooling partially compensates for a lack of an education in the arts, then the specific influence of arts education may only show up for students who have had limited schooling. This question frames the last set of analyses.

When looking at print-media involvement (reading and/or listening to books, plays, and poetry), findings revealed that there was no shift in the effects based on the influence of the other type of education. The effect of arts education on print-media involvement remained independent of overall educational attainment; in other words, more arts education resulted in more involvement both at the low and the high ends of the educational spectrum. This is remarkable considering the prominent role of reading in so many aspects of education.

However, when looking at arts attendance and audio- and video-media accessed arts consumption, findings revealed that the effects of general education changed, depending on how much arts education one had received. Specifically, those people with high levels of general education *and* a more extensive arts education experience were much higher in their arts attendance and consumption than were those with comparable general education but little or no arts-specific education. Similarly, arts education had a more powerful impact on arts attendance for individuals of greater overall educational attainment; whereas arts education alone, without the larger socialization that education provides, had less of an impact on arts attendance. A similar pattern was observed regarding rates of watching televised or video-recorded arts events. This would suggest that this type of arts participation and arts attendance are operating along the same dynamic: arts education makes more of a difference when students have the larger socialization of education in place. In general, these two different aspects of education reinforced each other, making the final impact on arts attendance much stronger.

Curiously, those people with high levels of general education and a more extensive arts education spent less time, rather than more, creating arts (writing, composing, painting, drawing, etc.). The effect of arts education on arts

creation had a very different meaning relative to an individual's overall education. Although arts education did increase the amount of arts creation for all individuals, it was more important for those who had less education in other disciplines. For example, a student who dropped out of high school having received a great deal of arts education (in or out of school) created far more arts as an adult than did a similar person who attended college.

Finally, it was observed that arts education helped equalize the effects of overall education on arts listening. People without any arts education were very differentiated according to their educational background with regard to their arts listening. As arts education increased they became more similar to each other, to the degree that among people with a great deal of arts education, college graduates and high school dropouts exhibited comparable arts listening habits.

Introduction

The Role of Arts Education in Defining a Uniquely Diverse American Culture

American culture is unique in its incorporation of a diversity of artistic traditions. In order to ensure the continued definition of our American culture, each successive generation of Americans must gain basic cultural experiences so that they are accustomed and equipped to contribute to or participate in their national artistic culture. Arts education lies at the center of this proposition, one that has its place in any discussion of national purpose and identity. For the elements of American culture are transmitted via exposure, experience, skill, and understanding in the arts, gained through socialization and arts education. Toward this process, it is crucial to understand the effect of arts education on arts participation in order to plan the goals, content, and context (public, private, and parochial school, or private community-based) of our efforts at arts education. The purpose of this report is to distinguish broad patterns of arts education and arts participation among the American public and to investigate the relationship between arts education and arts participation as it applies to all Americans.

Connecting Arts Education and Arts Participation

Contemporary reports on arts education have emphasized the intrinsic value for Americans of an education in the arts; that is, the position that it's important to learn about the arts because (1) they are subjects worth knowing in their own right, with identifiable bodies of instructional content; and (2) they are ways of thinking, knowing, and learning about the world.[11] From this viewpoint, arts education makes a contribution to American society that cannot be annexed by any other opportunities provided by schools or any other arts or social agencies; in short, an education in the arts valued for its own sake. Also recognized is the role arts education plays in transmitting and understanding American culture, enabling students to become informed consumers of the arts; giving students a sense of shared community; allowing students to discover their artistic potentials, fostering their creativity; developing a view of the arts as essential to daily life, and supporting the acquisition of knowledge in other subjects.

Inherent in the intrinsically artistic view of arts education, as well as in the broader affirmations about the benefits and purpose of arts education, is the goal of connecting people with their national culture through their participation in the arts. For when people attend an arts performance, create art, or access the arts through the media (among other possibilities for arts participation), this practice reflects not only aspects of their life experience and personal situation, or their innate artistic potential, but also their education in the arts. It is these relationships between personal background, arts education, and arts participation that are explored in this report using data from the SPPA92.

Understanding these associations is critical to the discussion about arts education policy at a time when (1) individuals and organizations concerned with arts education have offered recommendations regarding school arts education curricula, structure, funding, testing, teachers, policy, and research; (2) the U.S. Department of Education has accepted arts standards that define what every American should know and be able to do in the arts from the Consortium of National Arts Education Associations (Associations, 1994); and (3) the National Assessment of Educational Progress, scheduled for 1997, will be a national assessment of students' achievement in the arts. Aside from this public attention to arts education, the majority of Americans retain private goals for their children that include having them learn about the arts (*Americans and the Arts VI*, 1992). In holding this personal value system and in undertaking these types of policy initiatives and recommendations, as a nation and as individuals, we not only deem arts education as a goal, but imply that arts education is a means toward an end—a means toward participation in the arts as adult citizens.

Analytical View of Arts Participation

In this report, arts participation as an outcome of arts education and patterns of arts participation by personal background (gender, race/ethnicity, socioeconomic status) are considered. Through statistical analyses a determination is made as to how much of the patterns of Americans' arts participation is attributable to arts education, sociodemographic characteristics, and involvement in leisure activities. The SPPA92 also allows for the distinction between arts education provided in schools and in the community. Explored also are the effects of overall general educational attainment on arts participation in order to compare them with the effects of arts-specific education. Thus, it is possible to provide information to agencies and individuals responsible for arts education policy on:

- the strength of arts education as a predictor of arts participation, even after taking into account sociodemographic characteristics and lifestyle.
- the ability of arts education to mediate the influence of sociodemographic differences on arts participation.
- the relative effects of school-based vs. community-based arts education.
- the relative effects of arts education and general education on arts participation.

Sociodemographic Background

Obviously factors other than arts education influence arts participation, including sociodemographic characteristics such as gender, race, ethnicity, and socioeconomic status. In this report, differences in arts participation based on these characteristics are determined, along with the effects of arts education on arts participation, taking into account the influence of these other factors.

Based on previous research, it is anticipated that differences in arts participation by sociodemographic background will be discovered.[12] However, it is not the aim of this report to investigate the effects of sociodemographic characteristics on arts participation.[13] Rather, the effects of gender, race, ethnicity, and socioeconomic status on arts participation are considered in order to determine how arts education may reduce or remove any differences in arts participation by sociodemographic background.

School-Based and Community-Based Arts Education

As a nation, Americans value the concept of equal opportunity and view schools as institutions charged with upholding this ideal. This educational value is related to David Pankratz's (1987) concept of aesthetic justice, which he defines as the equitable distribution of aesthetic wealth among members of a society. Pankratz identifies that:

To achieve an equitable distribution of aesthetic wealth, it is essential that a society's members have ample opportunities to experience objects of high aesthetic value, whatever their geographic location or social stratum. For aesthetic justice to prevail, policymakers have an additional obligation to increase the aesthetic capability of a society's members, i.e., those critical and appreciative skills needed for persons to best take advantage of the aesthetic opportunities presented to them (p. 17).

In recognition of these concepts of educational and aesthetic egalitarian-

ism, it is critical to view schools as important arts education agencies and to consider their relationship to arts education institutions that are based in the larger community, outside of school.[14] The following discussion, therefore, considers the comparative effects of school-based and community-based arts education on arts participation, paying particular attention to the sociodemographic characteristics of those individuals who learn about the arts in each type of arts education setting.

Relative Effects of Arts Education and Overall Educational Attainment

There are many studies that substantiate the strong, positive relationship between overall educational attainment and arts participation.[15] In this report, the effects of overall educational attainment on arts participation are compared with those of arts education. This is in keeping with contemporary arts education writings that promote arts education as an intrinsically worthwhile endeavor, thus supporting the development of an arts education-specific policy that goes beyond advocating increased levels of general education as a way to increase arts participation for more people.

Organization and Content of This Report

In Part 1 the conceptualization of arts participation and arts education is detailed, and the variables from SPPA92 that were used in this analyses are defined. Also explained is the general plan for data analysis. In Part 2 a brief explanation is offered on how to read and understand the results of these analyses as represented in the tables.

In Parts 2 and 3 the effects of arts education and the comparative effects of arts education and overall education on arts participation are considered. Each part, or section, (1) frames the analysis based on contemporary issues in education or arts education; (2) presents the related analytical model, including discussion of any variables unique to a particular section; (3) discusses the results of the effects analyses; and (4) concludes with an overview of each section's results.

Summary of Research Methods Used

PART

I

Description of the SPPA Surveys

The 1982, 1985, and 1992 Surveys of Public Participation in the Arts were commissioned by the National Endowment for the Arts. They were designed to be the most comprehensive national surveys on arts participation.[16]

In this monograph data from the 1992 survey only is used.[17] The response rate was more than 80 percent and the sample was limited to individuals over the age of 18 at the time of the survey. The data are weighted so as to be representative of the 1992 U.S. population with regard to age, race, and gender. Questions about live attendance and media participation during the previous 12 months were asked of 12,736 individuals during the period January-December, 1992. A second set of questions about arts education, leisure activities, music preferences, desire for additional arts participation, and personal arts creating or performing was answered by 5,701 individuals during the second half of 1992.

Determining the Effects of Arts Education on Arts Participation

There are many reasons people participate in arts activities. One can easily speculate that a tentative list might include one's arts experiences as a child, parental role models, financial resources, socioeconomic status, degree of participation in leisure activities, and finally, for purposes of this report, one's education in the arts.

One approach is to describe how rates of arts participation increase/decrease for persons with different amounts of arts education; to say, for example, that the attendance rate at classical music concerts for people with some arts education was more than twice that of people with none. Examining arts participation rates in this way would describe a general trend of increased arts participation rates for people of higher arts education levels but would not explain any underlying reasons why this was the case.[18]

Another approach would be to conduct analyses that describe the type and strength of the relationship between arts education and arts participation. To do so one would conduct a correlation analysis. A positive correlation would indicate a relationship between arts education and arts participation such that as arts education increased, arts participation increased, whereas a negative correlation would imply the opposite.[19] A positive correlation between arts education and arts participation, no matter how strong, would not indicate that arts education *caused* increased arts participation. The possibility would remain that another trait associated with arts education is behind more educated people's increased arts participation. For example, although people with more arts education may have higher rates of arts participation, and a strong statistical relationship may exist between the two, this could be explained by the fact that those with more arts education have greater financial resources with which to support their arts participation.

Describing the rates of arts participation for persons of different arts education levels and the association between the two addresses questions of how much and to what degree arts education is relevant to arts participation; it does not explain why. What is needed is an approach that contrasts the influence of arts education on arts participation with that of other traits associated with arts participation; that is, by taking into account other known influences on arts participation. Given the breadth of the information supplied by the SPPA92, it was possible to consider the effects of arts education on arts participation *net* of socioeconomic status and elements of individual leisure activity that may compete with the arts for resources, such as time and money.

Role of Personal Background

It would be illogical to expect that arts participation would be completely independent of personal background, with members of all groups (racial, ethnic, or gender) participating at a comparable degree. To do so would be to ignore the roles socialization, personal preference, and personal history play in defining individual choice and developing group and personal identity. However, in these analyses the effect of those factors connected with group status were removed, thereby isolating the effects of birth-determined membership in a particular group; in other words, to consider the *net* effect of group membership, or that portion predetermined by birth. To find such net effects would put forth the unfortunate proposition that access to arts education in the contemporary United States may be determined by factors over which a person has no control.

General Analytic Plan

The analytic plan appropriate for this type of inquiry is based on analysis of covariance, following a path-analytic model.[20] Even in its simplest form, the theoretical model demonstrates the "path" quality implied by its name (see Figure 1).

In this general analytic model, arts participation (C) is the outcome; and arts education (B) is the factor of interest. Its effect on the outcome is explored after taking into account sociodemographic characteristics (A) of the respondents. Of equal importance (given the consideration of egalitarian goals for arts education and participation) is the ability of this model to estimate the power of arts education to mediate (reduce or remove) any effects of sociodemographic characteristics on arts participation. Then the effects of arts education on arts participation are investigated, after taking into account various aspects of one's lifestyle that may compete with participating in the arts for one's time and other resources (Figure 2).

In the complete model, arts participation occurs as the result of arts education (B), as influenced by sociodemographic characteristics (A), and after considering the competing effects of one's lifestyle (C). Although there certainly are other factors that influence arts participation that were not part of this survey, and therefore cannot be taken into account by the model, data from the SPPA do allow for the consideration of how much people participate in the arts as functions of arts education, sociodemographic characteristics, and lifestyle.

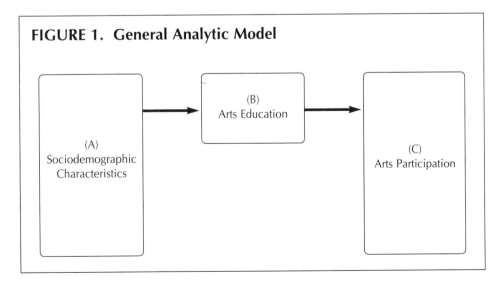

FIGURE 1. General Analytic Model

(A) Sociodemographic Characteristics → (B) Arts Education → (C) Arts Participation

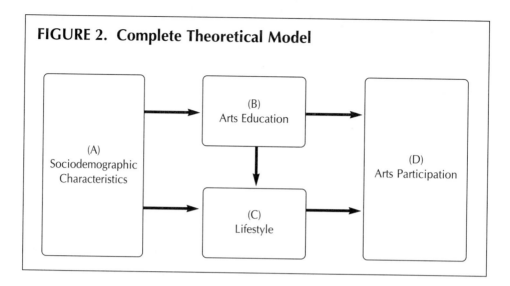

FIGURE 2. Complete Theoretical Model

Description of Variables

This section details the construction of the measures of arts education and arts participation, sociodemographic background, and a specific lifestyle factor that will be used in all of the analyses based on the theoretical model. Variables that are unique to specific sections of this report are described therein. Because composite variables were constructed using available information rather than deleting cases, there were very little, if any, missing data on these measures.

Indices of Arts Education and Arts Participation

Arts Education

Because each survey item has a limited range of response, the reliability of any one item for reporting experience or education in the arts is very limited. Therefore it was necessary to combine arts education in different art forms at different time points.[21] Thus, a person who took only music lessons in childhood has a lower *arts education density* score than a person who took both music and art lessons as a child, and this person in turn has a lower score than one who took both types of lessons both in childhood and as a teenager. This combination allows for the use of a weighted estimator of arts education that is more stable by individual and that has a more reliable distribution, one that is necessary for the type of statistical techniques used.

Preliminary analyses employed measures of arts education duration and

arts education concentration.[22] Results yielded a high correlation between the two measures and overall results that were not different from those using the more comprehensive measure. The more general consideration of arts education was labeled Arts Education Density (Table 1).

Arts education, whether received in school or in the community outside the school, was also considered. "School" refers to the respondent's school of attendance and not necessarily a public institution, though the compulsory nature of education in the United States is in contrast with the more elective nature of community-based, private education.[23]

TABLE 1. Arts Education Indices (SPPA92)

Index	Description (range)
Arts Education Density	The number of art forms in which respondent had classes, summed across five time periods; 1 point awarded for each art form and one for each period. This is a standardized scale of duration, weighted by number of art forms. (0-40)
Arts Education Agency	
Community	One point awarded for each art form in which respondent received instruction in the larger community, outside of school while of school age (through 17); summed for all art forms and standardized. (0-8)
School	One point awarded for each art form in which respondent received instruction in school while of school age (through 17); summed for all art forms and standardized. (0-8)

Arts education is described as instruction in those art forms that were included in the 1992 survey (Table 2). Although the art forms surveyed are a broad representation of those in which Americans participate and are more diverse than in earlier versions of the SPPA, they are primarily those art forms of particular interest to the National Endowment for the Arts as an agency of the federal government. Despite the great value of this list, it would be unwise to interpret this list as the only arts in which Americans participate.

TABLE 2. Arts Activities by Art Forms Surveyed

Arts Activity	Art Forms Considered
Arts Education Lessons	music, visual arts, acting, ballet, other dance, creative writing, art appreciation/history, music appreciation/history
Arts Production Art creation	pottery, needlework, photography, painting, creative writing, musical composition
Art performance	jazz, classical, opera, musical play/operetta, choral music, dramatic acting, ballet, other dance forms
Arts Consumption Attendance	jazz, classical, opera, musical play/operetta, nonmusical play, ballet, other dance forms, art museum/galleries
Audio media	jazz, classical, opera, musical play/operetta, nonmusical play
Video media	jazz, classical, opera, musical play/operetta, nonmusical play, dance, program about art/artists
Print and print-related media	read plays, read poetry, read novels or short stories, listen to a reading of poetry, listen to a reading of novels or books

Arts Participation

Ethnomusicologists, sociologists, and psychologists have considered arts participation from various perspectives.[24] Although the SPPA may not allow consideration of all theoretical definitions of arts participation, it does permit analysts to view three dimensions of arts participation that are central to any discussion of arts and arts education policies: attendance at arts events, arts production, and accessing the arts through media.[25] The questions and organization of the SPPA92 also allowed for consideration of arts consumption (attendance and media-accessed participation) vs. arts production (performance and creation) (Table 3).

TABLE 3. Arts Participation Indices (SPPA92)

Arts Consumption	
Attendance	the number of arts performances attended, summed across arts forms
Audio media	the number of art forms respondent listened to: radio broadcast or audio recording
Video media	the number of times respondent watched the arts (TV or VCR)
Print and print-related media	the number of times respondent engaged in reading print literature or listening to recordings of print literature
Arts Production	
Creation	1 point for each art form created, another point if the artistic creation was published, displayed, or performed in public
Performance	1 point for each type of art form performed; another point if the performance was in public

Note: All indices are standardized (mean = 0; s.d. = 1)

Respondent Background Variables

Gender, race/ethnicity, and socioeconomic status were considered as exogenous variables, since they describe traits that are not impacted by any other variable in the model. Descriptions of these variables and their construction appear in Table 4.

In all analyses, race and ethnicity were entered as dichotomous, or "dummy-coded" variables. That is, respondents were given a 1 if they were a member of the group in question; an 0 if they were not. As is necessary, one group is designated the comparison group. In this report's effect analyses, white served this role.

In preliminary comparisons, it became evident that African American, Hispanic, Asian, and white respondents had very different experiences in both arts education and participation. Thus it was necessary to consider the effects of each group separately. Although Native Americans had different experiences as well, there were so few of these individuals surveyed (N=16) that it

TABLE 4. Respondent Background and Lifestyle Variables Used in Analyses (SPPA92)

Construct Variable	Description
Gender	
Male	dummy-coded Gender variable. Female = 0; Male - 1
Race/Ethnicity	
African American	dummy-coded Race variable. White, Hispanic, Asian = 0; African American = 1
Hispanic	dummy-coded Race variable. White, Asian, African American = 0; Hispanic = 1
Asian	dummy-coded Race variable. White, Hispanic, African American = 0; Asian = 1
Socioeconomic Status	
SES	Standardized composite indicator of socioeconomic status. Variables included were family income, number of cars owned, and level of parents' education
Lifestyle Considerations	
Leisure index	Number of hours spent watching TV per day plus 1 point for each type of leisure activity in which respondent participated

was appropriate to exclude them from these analyses, given the technical requirements of the statistical procedures necessary to answer the research questions.

Lifestyle Considerations

Lifestyle is represented as a score on the *leisure index* (LI). The LI is the sum of the number of hours the respondent reported watching television per day and the number of leisure activities in which respondent participated (Table 4). Leisure activities surveyed in the 1992 SPPA include movies, sports (viewing and participation), amusement parks, exercise, outdoor activities, volunteer/charity work, home improvement/repair, and gardening for pleasure.

Effects of Arts Education on Arts Participation

PART

II

T his section examines how an individual's access to arts education might reflect one's social background, leading to differences in arts participation. Specifically explored is the question of whether gender and racial/ethnicity differences, or socioeconomic status differences in access to arts education have consequent impact on arts participation.

Data Source

This investigation uses information gathered from the SPPA92.[26] Of the total sample size of the survey, 12,736, over 5,000 specifically responded to items concerning (1) personal arts participation by performing or creating, (2) attendance at arts activities either in person or through the media, and (3) participation in other leisure activities. In addition, these individuals provided some limited information about their earlier in-school and out-of-school education in the arts.

Measures

Three sets of measures were used for these analyses.[27] The first set, capturing individual demographics, includes dichotomous ethnic measures for Asian, Hispanic, and African American (with white as the control group); a dichotomous measure identifying males; and a composite measure of an individual's personal income, high-status possessions, and parent education, as an indicator of SES. The second set of measures, reflecting arts education background, used a measure of arts education density, a standardized scale weighted by the number of art forms in which an individual received education, as well as by the number of time periods in which a person received that education. In addition to this overall estimate, separate indices for education received in school were created (school-based arts education) and for that received out of school (community-based arts education). These two variables considered arts education obtained only through age 17, whereas the arts education density index also included lessons obtained as an adult.

The third set of measures reflects personal arts participation, which is considered as either consumptive or productive in nature. The first two composites are performance and creation—each a scale of the number of art forms the respondent reported producing, weighted by whether it was done for public display. The last three measures in this set indicate arts consumption: attendance sums the number of live performances attended weighted by the number of art forms attended, whereas consumption through media were separated into audio (radio, compact disc, tape recording) and video media (TV, VCR). Finally, an index was constructed measuring a person's involvement with print media and print-related media (audio recordings of print literature).

Understanding Analysis Tables

The primary results of these analyses using standardized regression coefficients are reported so that the size of each can be compared accurately. This section explains the relevant technical terminology so that readers can better understand the tables that are used to present the findings.

The amount that arts education contributes to later participation in the arts is referred to as "the strength of relationship" between arts education and arts participation after taking into account other influences on arts participation. This strength is determined by comparing the relative size of the standardized coefficients in the tables, ignoring the presence or absence of negative signs. When present, a negative number indicates that as one factor gets larger, the outcome gets smaller; for example, one might expect that as one's time in front of television increases, one's participation in the arts may decrease. A positive number indicates that as one factor gets larger, the outcome increases; for example, one might expect that as one's income grows larger, the amount one spends on the arts may increase.

Each of these standardized regression coefficients (sometimes referred to by the Greek letter beta) indicate the *unique* relationship between that factor and the outcome—after taking each of the others into account.[28] For example, the third column of coefficients in Table 5 (Attendance), shows beta = .32 for Arts Education Density, and beta = .08 for SES. Thus, the data indicate that (1) as arts education increases, people participate in the arts more (the beta is .32, not −.32), even after ethnicity, gender, and socioeconomic status are taken into account; (2) as SES increases, people participate in the arts more, even after taking ethnicity, gender, and arts education into account (beta for SES is also positive); and (3) arts education is four times as "strong" a predictor of participating in the arts as SES (.32 is four times as large as .08).

The variables that are coded only with an 0 or a 1 (such as the predictor labeled Male) show the amount to which the group coded 1 (in this case, males) differs from the group coded 0 (females). Thus males are more likely than females to attend arts presentations (the .02 coefficient for Male is positive).

TABLE 5. Effects of Arts Education and Sociodemographic Characteristics on Arts Participation

	Production		Consumption			
	Performance	Creation	Attendance	Video Media	Audio Media	Print Media
Predictor	Beta	Beta	Beta	Beta	Beta	Beta
African American	−.06***	−.05***	.03*	.01	.13***	.01
Asian	.01	.01	.001	.01	.003	−.02*
Hispanic	.01	.01	.004	.02	.03**	−.04**
Male	−.01	−.17***	.02*	.01	.07***	−.08***
SES	−.003	.03*	.08***	−.005	.13***	.09***
Arts education density	−.01	.19***	.32***	.16***	.42***	.40***
R^2	.01**	.08***	.12***	.02**	.22***	.21**

*p ≤ .05. **p ≤ .01. ***p ≤ .001.

Analyzing data sets as large as the SPPA92 will yield some statistically significant results due to chance. Therefore it is important to understand that the level of probability represents the likelihood that the particular effect occurred due to chance. The importance of any given relationship is shown in the tables by the absence or presence of one, two, or three stars, explained at the bottom of each table. Looking specifically at the effect of arts education on video-media arts consumption (column 4, Table 5), the probability of observing this relationship by chance alone would be fewer than one time in a hundred (** = p ≤ .01). Also note that the difference between being African American, Asian, or Hispanic compared to whites on watching arts events on television (video media) could occur as a result of chance five or more times out of a hundred (no stars on any of the betas). Given that the probability has been set more conservatively than this, specifically less than 5/100, findings indicate that there are no differences between ethnic groups when it comes to arts television viewing—in short, that video–media-based arts participation is independent of race or ethnicity, after one takes into account differences in socioeconomic status and arts education.

Finally, each analysis (columns in Table 5)—each combination of predictors, or model—explains some part of the overall outcome. A perfect model would be able to predict the outcome 100 percent of the time just by knowing the values of those predictors. A totally useless model would predict the outcome 0 percent of the time. In general, information from surveys is able to predict *at most* about 20 to 40 percent of the variance in the outcome, only because the responses people give to surveys is quite random (Cook & Campbell, 1979). The amount of the outcome predicted by each combination of variables is represented in the table by the value of R^2 as a decimal (converting to a percent requires multiplying the R^2 value by 100). For example, looking across the bottom row of Table 5 indicates that the combination of predictors being considered best explains audio-media arts consumption, as the amount of this outcome explained (22 percent, as $R^2 = .22***$) is the greatest of the six types of arts participation.

Analysis

First, differences in arts education by respondent's race/ethnicity, gender, and socioeconomic status were investigated. Then the combined effects of these sets of background measures were explored using simultaneous regression—demographic information combined with education in the arts (both general and separated into inside and outside the school) as mediated by competing leisure interests. This analysis was run for each of the six outcomes. The analytical model is shown in Figure 3.

Results

Sociodemographic Characteristics and Arts Education

Data in Table 6 show the results of personal background comparisons on arts education.[29] Access to arts education differed according to a one's personal background. First, males received significantly less arts education than females, more the case in community than in school-based environments (school beta = −.07*** community beta = −.19***). In other words, although males were slightly less likely to take arts courses in school, they were at a much greater disadvantage in getting additional lessons or education from a community setting. Second, persons of different racial/ethnic backgrounds gained different degrees of arts education, with African Americans and Asians demonstrating less arts education than whites and Hispanics, who were com-

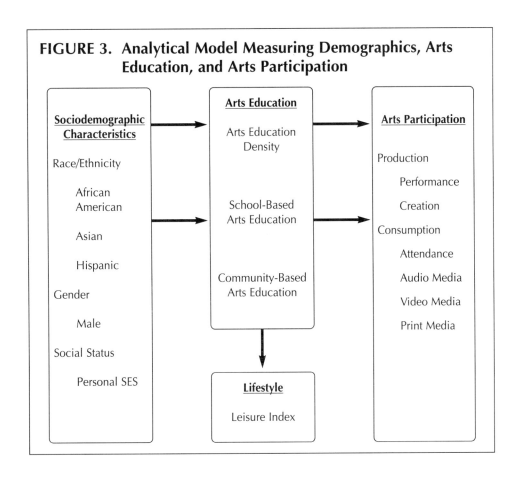

FIGURE 3. Analytical Model Measuring Demographics, Arts Education, and Arts Participation

parable in this regard (column 1). It is noteworthy that this differentiation of arts education by race/ethnicity was only the case for community-based arts education and not for school-based arts education: whereas Asians, African Americans, and Hispanics each participated less in community-based arts education than did whites, the amount of school-based arts education gained by individuals in all racial/ethnic groups was comparable.

Finally, in general, having an education in the arts had less to do with race/ethnicity and more to do with SES as increased social resources corresponded with more arts education (betas = .32***, .24***, and .26*** for general, school-, and community-based arts education, respectively). Indeed, socioeconomic status was the strongest determinant of arts education, even after controlling for the other sociodemographic characteristics in this analysis.

Given that arts education differed by personal background, particularly SES, the research must explore not only whether arts education predicts arts participation, but if the identified differences in arts education by personal background carry over to arts participation. In order to do this, two questions

must be asked: Does arts participation differ by personal background? and if so, Does arts education reduce or remove any of these differences? These issues are now explored.

TABLE 6. Differences in Arts Education by Race/Ethnicity, Gender, and Socioeconomic Status

Predictor	Arts Education Density Index Beta	School-Based Arts Education Index Beta	Community-Based Arts Education Index Beta
African American	−.03*	.02	−.05***
Asian	−.03**	−.02	−.04***
Hispanic	−.02	.02	−.04**
Male	−.14***	−.07***	−.19***
SES	.32***	.24***	.26***
R2	.12***	.06***	.10***

*p ≤ .05. **p ≤ .01. ***p ≤ .001.

Sociodemographic Characteristics and Participation in the Arts

As was the case with arts education, differences in sociodemographic background extend to differences in arts participation (Table 7). Of the two arts production measures, demographic background showed slightly more differences in creating than performing in the arts (R^2 = .05*** and .01***, respectively). In fact, the only significant difference among groups for arts performance was that, net of gender and SES, African Americans had lower involvement with arts performance relative to whites (beta = −.06***). In looking at arts creation, the same was true for males relative to females (beta = −.20***) and again for African Americans relative to whites. Finally, the higher one's SES, the more one created in the arts (beta = .09***), though SES did not indicate anything regarding arts performance.

Looking at arts consumption, SES strongly predicted both live attendance and audio-media arts involvement (listening to recordings, radio) but was not as important for video-media arts consumption. This difference could reflect a direct link to the relative ongoing cost of buying tickets, recordings, and books compared to turning on a television, once one owns it. Another observed difference was that African Americans were significantly more likely to listen to recordings of music or stage presentations than their white counterparts, after taking gender and SES into account. Finally, males were noticeably

less involved with print media, and SES positively predicted this type of involvement. In other words, higher income individuals from more educated parents were more likely to read or listen to a recording of print literature, or at least to report having done so. These results suggest that video-media involvement is the most equitable type of arts consumption, but that SES still plays a restrictive role in determining all types of arts participation except arts performance.

TABLE 7. Differences in Arts Participation by Race/Ethnicity, Gender, and Socioeconomic Status

	Production		Consumption			
	Performance	Creation	Attendance	Video Media	Audio Media	Print Media
Predictor	Beta	Beta	Beta	Beta	Beta	Beta
African American	−.06***	−.05***	.02	.01	.12***	.003
Asian	.01	.002	−.01	.002	−.01	−.04**
Hispanic	.01	.01	−.003	.02	.02	−.05***
Male	−.01	−.20***	−.02	−.02	.01	−.13***
SES	−.003	.09***	.18***	.04***	.26***	.22***
R^2	.01***	.05***	.03***	.01*	.07***	.07***

*$p \le .05$. **$p \le .01$. ***$p \le .001$.

Effect of Arts Education on Participation in the Arts

Having determined differences in arts participation for people of different sociodemographic background, consideration was then given to the mediating effects of arts education (as estimated by the arts education density index) on arts participation.[30] As before, the only background factor predicting participation in arts performance was ethnicity, with African Americans being somewhat less involved in this type of arts participation than whites (Table 5). Interestingly, those who had more arts education did not necessarily perform more than others. For the other outcomes, education in the arts was the strongest predictor (range of betas = .16*** (video media) to .42*** (audio media)), even more powerful than SES or personal background. In addition, taking differences in arts education into account decreased the net effect of SES (personal income, number of high-status possessions, and background education of parents), in most cases cutting the effect at least in half.[31] Thus, the impact of socioeconomic status on involvement in the arts occurs through

differential access to education in the arts.[32] In short, the direct function of SES on arts participation is as a resource factor.

Comparison of Arts Education Agencies—School and Community

In this section, distinction is made between the effects of arts education obtained in the school and in the community (Table 8).[33] For every outcome except performance, both sources of arts education have an independent positive impact on the measure of involvement in the arts. Oddly enough, school-based education actually decreases the likelihood somewhat that individuals will continue to perform as adults (beta = −.03*). Of the remaining five indicators of personal participation in the arts, school-based arts education was the weaker of the two types of arts education for every outcome except creation of art (beta = .11*** for school-based compared to beta = .07*** for community-based). The largest difference between the effects of these two arts education agencies occurred with video-media consumption (beta = .10*** for community-based compared to .03* for school-based). There was no difference in predictive strength between these two arts education systems with regard to audio-media participation (betas = .19***).

When comparing the data in Tables 5 and 8, the portion of the variance explained by school- and community-based arts education was slightly lower (the same in the case of arts performance) than that of the full combined measure of arts education density.[34] In addition, the effects for SES were slightly weaker in the case of the more comprehensive arts education measure.

Conclusion

The questions of this section were to determine who received an education in the arts and how it may have influenced participation in the arts. This summary is organized around those two issues. Arts participation, both theoretically and via statistical methodology, was viewed as an outcome of arts education influenced by personal background (gender, race/ethnicity, and SES) that competes with other leisure activities for resources, such as time and money. Arts participation was considered globally (rather than by individual art form) and defined by the nature of the arts involvement; that is, was art produced (performed or created) or was it consumed (via live attendance, listening to the arts via audio media, watching the arts via video media, or being involved via print or print-related media)?

Education in the arts was viewed primarily in two ways: as a general arts education background gained across one's lifetime, and as delivered through

TABLE 8. Comparison of Effects of School-Based and Community-Based Arts Education on Arts Participation

	Production		Consumption			
	Performance	Creation	Attendance	Video Media	Audio Media	Print Media
Predictor	Beta	Beta	Beta	Beta	Beta	Beta
African American	−.06***	−.05***	.03*	.02	.13***	−.02
Asian	.01	.001	−.001	.001	−.001	−.01
Hispanic	.02	.01	.002	.02	.02*	−.03**
Male	−.01	−.18***	.02	.004	.05***	−.07***
SES	.001	.05***	.11***	.01	.17***	.12***
School-based arts education	−.03*	.11***	.09***	.03*	.19***	.03*
Community-based art education	.01	.07***	.17***	.10***	.19***	.08***
R^2	.01***	.07***	.08***	.01**	.16***	.05***

*$p \leq .05$. **$p \leq .01$. ***$p \leq .001$.

age 17 via one of two arts education agencies based in schools or in the private community, outside of school. The latter was established to allow for comparisons by arts education agency.

Who Received an Education in the Arts?

Findings revealed that socioeconomic status is a determinant to gaining an education in the arts in the United States: the higher one's SES—the higher one's level of arts education. Although this holds true for the population at large, SES is not the sole influence on the distribution of arts education across the population. Indeed gender, race, ethnicity all play a role.

Regarding overall arts education, women demonstrate a higher degree of arts education than men, as do whites and Hispanics compared to Asians and African Americans. Arts education that is gained in the private sector is differentiated by race/ethnicity, with nonwhites less involved than whites. On the other hand, arts education that is obtained in the school is not a matter of race or ethnicity, with African Americans, Asians, Hispanics, and whites engaged at comparable levels. In this regard, schools do seem to function as the more egalitarian source of arts education in the United States. However, SES

continues to influence those who receive school-based arts education, though less so than is the case for community-based arts education.

Impact of Arts Education on Patterns of Arts Participation

Arts education is the strongest predictor of arts attendance, arts creation, and accessing the arts through audio, video, and print media (Table 9).[35] Findings show that the more arts education people have, the higher their involvement with the arts. This is sustained even when taking into account influences on arts participation that were initially attributed to socioeconomic status, race/ethnicity, and gender.

The one exception occurred with arts performance, where knowing something about one's degree of arts education does not indicate anything about one's level of arts performance. It is also worth noting that the predictors which were considered here did a very poor job of explaining arts performance; clearly there are other influences on arts performance that are unaccounted for by the SPPA92 data.

TABLE 9. Effects of Arts Education on Arts Participation: Summary of Predictors From Final Models

	Production		Consumption			
	Performance	Creation	Attendance	Audio Media	Video Media	Print Media
Predictor						
African American	–	–	+	+++	o	o
Asian	o	o	o	o	o	–
Hispanic	o	o	o	++	o	–
Male	o	–	+	+++	o	–
SES	o	+.	+++	+++	o	+++
Arts education density	o	+++	+++	+++	+++	+++

Note: Symbol: + = positive predictor, – = negative predictor, o = not a predictor
 1 symbol = p ≤ ,05; 2 symbols = p ≤ .01; 3 symbols = p ≤ .001.
 Using this notational system for summarization purposes, one can read that arts creation was positively predicted by arts education at the p ≤ .001 level of probability.

There is no clear pattern of arts participation with regard to demographic background (race, ethnicity, and gender). For example, involvement with the arts via the print media is most differentiated by background; on the other hand, whites, Hispanics, and Asians attend and watch the arts at comparable levels.

A pattern was discovered in that, in all but one case (again, arts performance), differences in arts participation by socioeconomic status are reduced by taking into account differences in arts education. In other words, part of the reason for observed differences in the degree of arts participation by people of differing socioeconomic status is attributable to differences in their arts education. This implies that arts education facilitates participation in the arts for a broader cross section of the population than one would have found were it not for arts education in the United States, but SES still operates as a restriction to arts consumption (with the exception of video-media arts involvement, on which it was not an influence).[36]

Both school- and community-based arts education are positive and significant predictors of all types of arts participation, except arts performance, even after adjusting for personal background and SES. Community-based arts education is not related to arts performance, whereas increased engagement in school-based arts education actually means decreased levels of this type of arts participation as adults.

Community-based arts education is more strongly indicative of arts participation than school-based arts education, though one must remember the more *individualized* nature of the former relative to the primarily *group* instructional processes of the latter. The largest difference in predictive power is with video-accessed arts participation, with the effect of community-based arts education being more than three times stronger than that of instruction gained in the schools. Engaging in either of these two arts education agencies predicted comparable levels of listening to the arts via audio media.

The availability of leisure hours is not consistently related to arts participation.[37] Increased hours of leisure activities means decreased rates of arts attendance, listening to the arts, and creating art. For involvement with print media, the relationship is positive. There is no relationship between leisure activities and arts performance or watching the arts on television. In all cases except for audio-accessed arts participation, the addition of the rate of leisure activities into the analyses does not increase the amount of variability in arts participation that could be accounted for with just the other variables.

Comparative Effects of Arts Education and Overall Education on Arts Participation

PART

III

Introduction

This section compares the role of arts education and the larger socialization context of education and their effects on adults' participation in the arts. Given the effects of gender, racial/ethnicity, and socioeconomic status differences on individuals' access both to overall education and to instruction specifically in the arts,[38] this analysis considers whether these two factors have an effect on arts participation (consumption or production) that is either (1) independent—the effect of each after taking into account that of the other— or (2) interdependent—the effect of one type of education depending on the other.

Determining the nature of the relationship between education and arts education and their comparative effects on arts participation is important to individuals and agencies responsible for developing policy and programs designed to encourage arts participation. For although it may be encouraging to learn that higher levels of education lead to greater arts participation,[39] particularly at a time when a larger percentage of the population is obtaining more education (National Center for Educational Statistics, 1993), there is little opportunity or motivation, under this scenario, to do anything regarding national arts education policy except to promote an increased degree of general education. For if there is no effect of arts education on arts participation, beyond that of general education, an important justification for the development of arts education policy and programs is compromised.

Method

This investigation uses information gathered from the SPPA92. The same model and measures described previously in Parts 1 and 2 are employed. Education and arts education were compared in three ways by determining, first, the direction and magnitude of the relationship between the two types of education; second, the independent effects of each factor after taking the other into account; and third, the extent to which the effect of one type of education is contingent on the other.[40]

Results

Relationship Between Years of Education and Arts Education

Correlation analyses yielded positive, significant relationships between years of education and (1) overall arts education ($r = .42^{**}$), (2) school-based arts education ($r = .21^{**}$), and (3) community-based arts education ($r = .26^{**}$). This indicates that individuals with more overall education receive more education in the arts, both in general and in and out of school. It does not indicate that one type of education was gained as a (causal) result of acquiring the other, but that they occur together.

Given this information, the experiences of individuals of different educational backgrounds were examined using school-based and community-based arts education components. Overall, it is clear that education in the arts increased substantially with involvement in education (Figure 4). Interestingly,

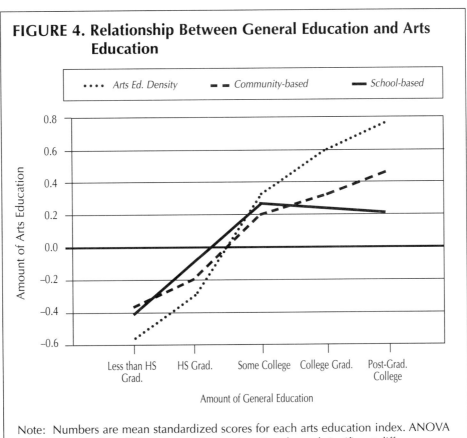

FIGURE 4. Relationship Between General Education and Arts Education

Note: Numbers are mean standardized scores for each arts education index. ANOVA results indicate that all three types of arts education showed significant differences ($p \leq .001$) over the categories of general education.

the regular increase in community-based arts education for each of the time points was not matched by an increase in school-based arts education. In other words, whereas more overall education translated to more community-based arts education, differences in school-based arts education primarily occurred between and around the point of high school graduation, with high school dropouts receiving much less than high school graduates, and those who went past high school into college—for any amount of time—having received more school-based arts education while of school age.

Independent Effects of Years of Education and Arts Education on Participation in the Arts

The combined impact of years of education with arts education was then explored taking into account other sociodemographic characteristics. More importantly, this analysis demonstrated the independent impact of each measure; that is, the effect of one type of education on arts participation, taking the other into account. The critical focus is indicated in the last two rows of results in Table 10.[41]

TABLE 10. Comparison of Effects of Overall Years of Education and of Arts Education Density on Arts Participation

| | Production | | Consumption | | | |
	Performance	Creation	Attendance	Video Media	Audio Media	Print Media
Predictor	Beta	Beta	Beta	Beta	Beta	Beta
African American	−.06***	−.05***	.03*	.02	.13***	.01
Asian	.01	.01	−.004	.01	−.004	−.03*
Hispanic	.02	.01	.01	.03	.04**	−.03*
Male	−.01	−.17***	.02	.003	.05***	−.08***
SES	−.01	.04*	.05***	−.02	.08***	.04**
Overall years of education	.02	−.02	.10***	.04*	.16***	.15***
Arts education density	−.01	.19***	.28***	.14***	.37***	.35***
R^2	.01*	.08***	.13***	.02*	.24***	.23***

As was observed in Part 2, none of the measures except those related to ethnicity has a predictive influence on performing. However, for each of the other types of arts participation, arts education had more than twice the predictive power of years of education in explaining an individual's involvement—creating, listening to, watching, attending, or reading—with the arts. Interestingly, although the effect of overall years of education is not as strong as specific education in the arts, there is a residual impact. In other words, more schooling increases a person's involvement in the arts, at least of a consumptive nature, even though education may not be specifically focused on the development of arts participation behaviors.

Interdependency of Education and Arts Education and the Effect on Arts Participation

This combination of independent effects of arts education and education, each acting separately on arts participation, suggests the possibility that overall education and arts education may have a *different* effect on participation in the arts based on how much of the other type of instruction one receives. Determining whether this is the case or not is necessary for an accurate and comprehensive interpretation of the preceding observations of the independent effects of arts education and education.

Results of analyses to test this possibility indicated that only in regard to print-media arts involvement were the effects of arts education consistent across levels of overall education. This is remarkable given that reading is an activity with a strong presence at all levels of education. One might expect therefore that the effect of arts education on involvement with print media would be different for varying levels of education. However, this was not the case.

For all other types of arts participation (except arts performance to which neither type of education was significantly related), the independent effects of education and arts education were different by level of the other type of instruction. Although this clouds any discussion of the independent effects of these educational backgrounds for these types of arts participation, it does offers a richer description of how these factors operate in tandem on arts participation.[42] To make better sense of the results, graphs have been constructed for each outcome for which the interaction between arts education and overall education was significant. It is important to recall that these graphs use the adjusted regression estimates, that is, those that take into account a person's race, gender, and SES (Figures 5A–6D).

Contingent Effects of Education on Arts Participation by Level of Arts Education

The effect of years of education on individuals' attendance at arts events, on the degree of listening to or watching the arts, or on arts creation, depends on the extent of one's education in the arts.[43] More overall education had a *stronger* effect on both attendance (Figure 5A), accessing the arts via audio (Figure 5B), and via video media (Figure 5C) for individuals who had more extensive arts education than it did for those with little or none. In other words, the socializing effects of education were augmented by arts-specific education to increase this type of arts participation, but they did not operate that way if a person had not received arts education.

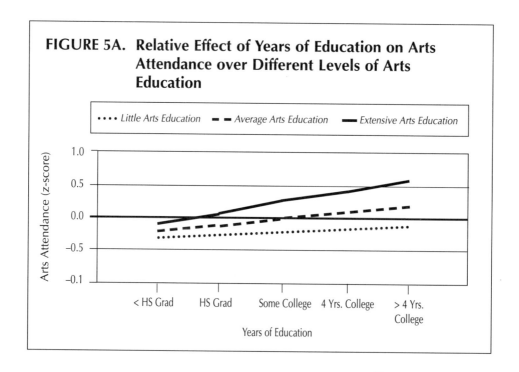

FIGURE 5A. Relative Effect of Years of Education on Arts Attendance over Different Levels of Arts Education

•••• Little Arts Education ▬ ▬ Average Arts Education ▬▬ Extensive Arts Education

Arts Attendance (z-score)

1.0
0.5
0.0
-0.5
-0.1

< HS Grad HS Grad Some College 4 Yrs. College > 4 Yrs. College

Years of Education

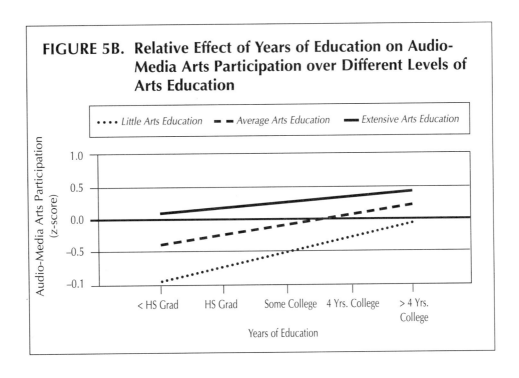

FIGURE 5B. Relative Effect of Years of Education on Audio-Media Arts Participation over Different Levels of Arts Education

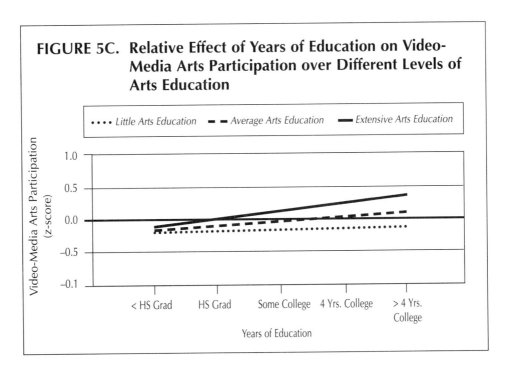

FIGURE 5C. Relative Effect of Years of Education on Video-Media Arts Participation over Different Levels of Arts Education

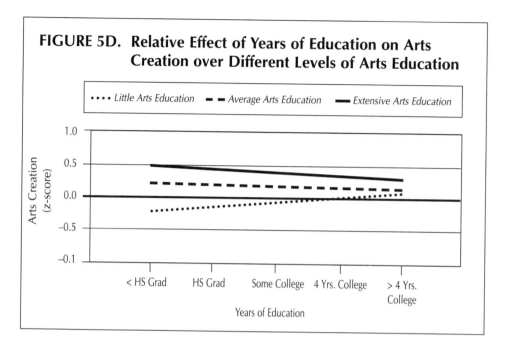

FIGURE 5D. **Relative Effect of Years of Education on Arts Creation over Different Levels of Arts Education**

This result is observable in the relative position of the lines in Figures 5A, B, and C, where the solid black line, representing standardized arts participation rates for people with extensive arts education, is consistently above the other two lines, which represent participation levels for individuals of average and little arts education. The general rising slope of these three lines demonstrates the positive effects of overall education for people of all levels of arts education.

On the other hand, education had less of an impact on participating in active listening to the arts and on creating arts (Figures 5B and D), even a negative one in the case of arts creation. For these activities, although specific education in the arts had the effect of increasing participation, this effect actually decreased with an increase in overall education. This is demonstrated by the fact that the three lines are more spread out at "<HS Grad" than they are at ">4 Yrs. College." This reduction of the spread suggests (1) a subsumed effect of education on arts creating and listening, one that diminishes with competing educational experiences (arts education) rather than being enhanced by those experiences, and (2) that the effect of arts education is sustained even with a constraining influence of increased overall education (the relative placement of the three lines remains the same). This may reflect generally the more arts-specific nature of arts education as compared to general education and, more specifically, the purpose and practice of creating art, which is a probable element of arts instruction.

Contingent Effects of Arts Education on Arts Participation by Level of Education

The effects here also varied by type of arts participation. Although patterns of arts creation and listening were each driven differently by arts education according to level of overall education, rates of arts attendance and video–media-accessed arts participation were affected in ways similar to each other.

Arts education had a significantly more powerful effect on arts attendance when combined with increasing years of education; that is, although it is true that as people gained more arts education they attended more arts performances, this relationship was even *stronger* for people with greater overall educational attainment (Figure 6A). Arts education had an impact on arts attendance, even for individuals without a high school education; but the effect was reinforced by the socialization education provided. This also held true for watching the arts on television (broadcast or VCR) (Figure 6B). These findings suggest that for these two types of arts participation, arts education makes more of a difference for individuals who have experienced the broader socialization that greater overall education seems to provide.

People with at least a college degree and a great deal of arts education created significantly *less* art than individuals who had dropped out of high school but who had also gained a great deal of arts education (Figure 6C). This is evident in the reversal of the relative position of the two outer lines from the order at "None" to the one at "A Great Deal." A reasonable supposition for this finding is that college graduates are involved in other activities that preclude time spent in creative pursuits, whereas high school dropouts are doing one of the things that they were trained to do via arts education, namely create. This suggests that the influence of an education specifically in the arts on arts creation is sustained independently of overall education and is thus more conducive to promoting adult creative behaviors than general (non-arts) education.

This contingent effect of arts education was even more dramatic when considering its effect on listening to the arts via radio broadcast or audio recording (Figure 6D). Listening habits were most different by level of education for individuals without any arts education, with people who have more education listening to more art forms than those with less education. (The greatest distance between the three lines is for individuals who have had no arts education.) This differential by education level was reduced as a person's level of arts education increased, to the point that people who had a great deal of arts education exhibited the same degree of arts listening whether they were high school dropouts or college graduates. In other words, arts education equalized the stark differences in arts listening habits that were based on how much education a person received.

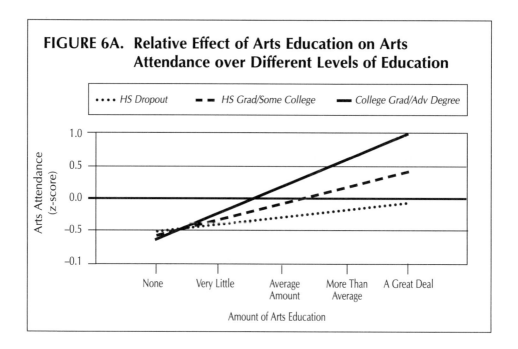

FIGURE 6A. Relative Effect of Arts Education on Arts Attendance over Different Levels of Education

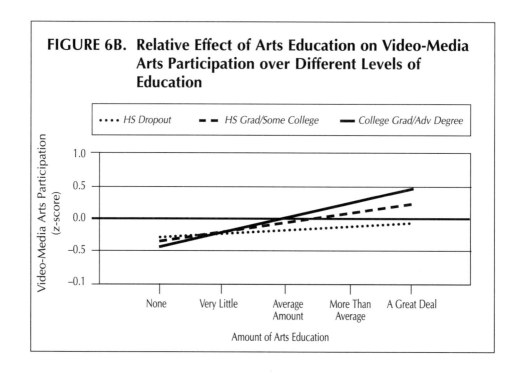

FIGURE 6B. Relative Effect of Arts Education on Video-Media Arts Participation over Different Levels of Education

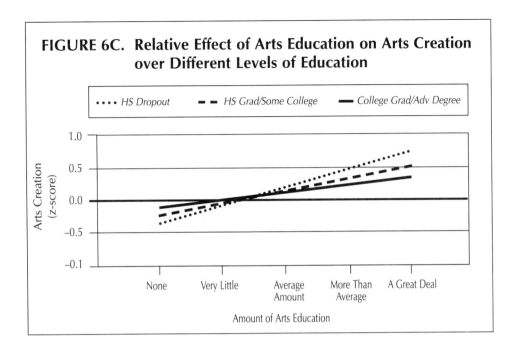

FIGURE 6C. Relative Effect of Arts Education on Arts Creation over Different Levels of Education

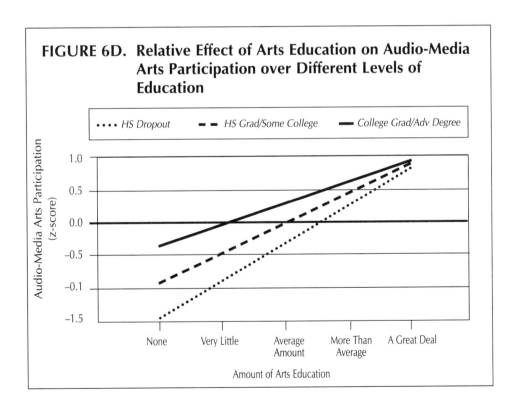

FIGURE 6D. Relative Effect of Arts Education on Audio-Media Arts Participation over Different Levels of Education

Summary

In this section, the role of arts education and the larger socialization context of education and their effect on adults' participation in the arts was compared. Having demonstrated the effects of gender and ethnic differences and socioeconomic status on individuals' access both to general education and specific education in the arts, this analysis explored whether these two factors have an independent impact, a contingent relationship, or a subsumed effect on arts participation, either by consumption or production.

First, findings revealed that there is a strong relationship between general education and arts education; that is, education in the arts increases substantially with additional education, and vice versa. Additionally, there are differences in school- and community-based arts education occurring between and around the point of high school graduation, with high school dropouts receiving much less school-based arts education than high school graduates.

It was then determined that both types of education have an independent positive effect on adults' arts participation, for every outcome except performance. However, although general education increases arts consumption (even after taking arts education into account), the positive and unique impact of arts education was in every case the stronger of the two. Thus it is clear that specific arts education, over and above that of educational experiences, has the greater effect.

Finally, the contingent impact of arts education relative to the amount of education one receives was explored. Varying relationships were found. For arts attendance and for watching the arts on television/video, there exists a contingent relationship between the two types of education, so that each increases the impact of the other over what it would be separately. The effects of arts education on arts creation diminish as the competing type of education increases (though all effects continue to be positive). For arts creation, education in the arts thereby subsumes the effects of education, so that arts education is most important for those individuals who have the least amount of overall education from which to draw. Lastly, the role arts education plays to expand listening habits among adults helps to equalize overall differences, bringing closer together those individuals who have very different levels of educational experience.

Summary and Conclusions

Introduction

In the introduction to this monograph it was suggested that arts education is one of the mechanisms through which a uniquely diverse American culture is defined and developed. This is because an education in the arts should provide the members of each subsequent generation with arts exposure, skill, and understanding, thereby encouraging and enabling full participation in the American artistic culture. To assess this supposition, it was necessary to gain a more complete understanding of how exposure to and education in the arts influenced people's participation in arts activities in the larger context of their learning and growing. Also toward this end, it was vital to understand the arts education process as part of a larger context, both in terms of its effect on individuals and its role in the fabric of a dynamic American culture. This is of particular importance at a time of increased public attention to national arts policy and arts achievement, and when the majority of Americans hold a private view that arts education is something they would like their children to have.[44]

The history of arts participation in the United States is inexorably linked to changes in the social hierarchy, to the emergence of arts-related technology, to the desire to establish an American culture, and to the societal value awarded to different arts traditions. In the contemporary United States, renewed importance is awarded to a multitraditional understanding of the arts and an interest in equality of opportunity and access to social institutions and traditions. These points are part of the basis of these analyses and are also consonant with the view of school as a social institution of egalitarian purpose. Thus it was necessary to consider the social distribution of arts education and arts participation and, in particular, the context and experiences of different racial/ethnic groups.

Analytical Process

In this report, arts participation was not viewed by individual art form, but globally, across art forms. Part 1 detailed the construction of indices of arts participation organized around the distinction between arts production

(creation and performance) and arts consumption (attendance, watching the arts on television, listening to the arts via radio broadcast or audio recording, reading print literature or listening to recordings thereof). This configuration of arts participation is comparable to that used in earlier analyses of the 1982 and 1985 SPPAs and reflects the organization of the 1992 survey.

The measures of arts education were defined as an overall index (arts education density) and two other indices that corresponded to the two arts education agencies differentiated by the SPPA92, namely school-based and community-based arts education. Demographic background included gender and race/ethnicity, specifically Asians, African Americans, Hispanics, and whites.[45] A standardized measure of socioeconomic status was created that included family income, parents' level of education, and the number of high-status possessions owned. Amount of leisure activity was represented by the sum of the numbers of hours spent watching television and the number of leisure activities pursued. This aggregation of data was designed in order to create variables that were more stable and reliable.

In this report, arts participation was viewed as (1) an outcome of arts education that is influenced by personal background and life experience, with these concepts being defined, in part, by race/ethnicity, gender, and socioeconomic status; and (2) as something that competes with leisure activities for an individual's resources, that is, time and money. While it is valuable to describe *rates* of arts participation,[46] it was the purpose of this report to define broad *patterns* of arts participation and to investigate the effects of arts education on these patterns. Particular attention was awarded to the possibility that arts education modified arts participation patterns that are based on those elements of personal background that are beyond one's control, such as race, ethnicity, and gender. In short, the question was asked: Did arts education facilitate arts participation for a broader cross section of Americans?

In Part 2 determination was made of the effects of arts education on arts participation and the comparative effects of arts education obtained in school vs. the community. Particular attention was awarded to the sociodemographic background of the individuals engaged by each of these arts education agencies. This was done in recognition of the notion of schools as social institutions inherently valued for providing equality of opportunity and therefore being of somewhat different purpose than educational institutions established and operating in the private sector.

An assessment of the comparative effects of arts education and of overall education on arts participation was presented in Part 3. This allowed us to differentiate between the larger socializing role of educational attainment and that of arts-specific education in predicting arts participation. This is important to the development of arts education policy that (1) does more than call

for increasing the degree of Americans' educational attainment as a means of increasing arts participation and (2) reflects the view advanced in contemporary arts education writings that an arts education is intrinsically valuable.

In summary, the results of these analyses were intended to shed some light on:

- the strength of arts education as a predictor of arts participation.
- the ability of arts education to mediate sociodemographic differences (race, ethnicity, gender, and SES) in arts participation.
- the relative effects on arts participation of arts education received in the schools and of that obtained from community-based arts education providers.
- the comparative effects of arts education and overall educational attainment on arts participation.

Summary of Results

In this section, the results of these analyses are organized around two questions: How does arts education influence arts participation? How do arts education and education work interdependently to affect arts participation? For each question, related results are discussed for each of the six types of arts participation considered, specifically attendance, creation, performance, and media-accessed arts participation (audio, video, and print media). The reader should keep in mind that the discussion of the effect of any factor on another refers to its *net* effect; that is, its effect *after taking into account* the influence of the other factors included the particular analysis, for example, gender, race/ethnicity, SES, or amount of leisure activity.[47]

How Does Arts Education Influence Arts Participation?

The answer here is simple: the richer one's arts education, the greater one's participation in the arts. Increased arts education means increased adult arts participation of all types, except arts performance. Arts education is the strongest predictor of arts creation and of all four types of arts consumption, stronger even than socioeconomic status and personal background. Although higher SES does translate into higher rates of arts consumption and creation, in most cases at least half of the differences in arts consumption and creation related to SES are due to differences in arts education. Americans watch the arts on television (broadcast or VCR) at rates that are comparable for all racial/ethnic groups, for men and women, and for all degrees of socioeconomic status. The only differentiating attribute here is one's degree of arts ed-

ucation, with increased arts education yielding increased accessing of the arts via video media. However, many of the influences on this type of arts participation are not represented by the factors included in the analyses.

School-Based and Community-Based Arts Education

Socioeconomic status is the strongest determinant of obtaining an arts education. However, this is slightly less the case for arts education provided in schools than it is for arts education offered in the community outside of school. Indeed, members of all racial/ethnic groups attained comparable levels of school-based arts education, whereas the reverse was true for community-based arts education, with nonwhites accruing significantly less education in the arts than whites. This suggests that school-based arts education is more accessible to a broader cross section of Americans than is arts education offered in the private sector. The fact that this racial/ethnic stratification of arts education remained after adjusting for socioeconomic status indicates that it is not a matter of social or economic affluence but that schools, truly, are the more egalitarian source of arts education in the United States.

The relative effects on arts participation of the arts education obtained via these two arts education agencies also differed by type of arts participation.[48] People who gain a community-based arts education exhibit higher rates of arts attendance and video- and print-media arts involvement, relative to individuals whose arts lessons were taken in school. School-based arts instruction is the stronger determinant of arts creation. Individuals who gain their arts education through either arts education agency demonstrate comparable degrees of accessing the arts via audio media. Adults who take arts lessons in schools have lower rates of arts performance, whereas taking lessons outside of school does not result in any change in the likelihood of performing arts as adults, despite the performance/production orientation of much of the arts instruction in either context.

How Do Arts Education and Education Work Interdependently?

The answer to this question varies by the type of arts participation and particularly by levels of arts education and overall education.[49] After determining that there was a positive relationship between overall educational attainment and arts education, findings confirmed that their effects on arts participation were interdependent, meaning that the effects of each were *different depending on the level of the other*. This was the case for all types of arts participation except print-media involvement and hinders simple conclusions about the effects of either arts education and education in comparison to the other.[50]

For this reason, in this section the discussion is confined to the interdependent effects of arts education and education.

Education makes more of a difference in arts consumption (except for print-media involvement) for people with more extensive arts education than it does for those with little or no arts education background. In these cases, the socializing effect of education is augmented by arts-specific education. However, people with more arts education create more art, though this is less the case for people with higher levels of overall education. This indicates that arts creation is more easily fostered within an arts-specific education, above and beyond the inhibiting effect of increased (non-arts) education.

The effect of arts education on arts participation across levels of overall education also varies by type of arts participation. Rates of arts attendance and watching the arts on television (broadcast or VCR) are higher for people who have more arts education, but this is even greater for individuals at a higher level of overall education. Apparently, arts education makes more of an impact on these two types of arts participation when the broader socialization provided by overall education is in place than it does by itself. This is not the case regarding arts creation: arts education is more important to arts creation for people with less overall education, to the degree that a high school dropout with a great deal of arts education creates far more art as an adult than does a person of similar arts education background who went to college. The number of art forms people listen to via radio broadcasts or audio recordings varies greatly based on their arts/educational background; specifically, individuals with more education have broader listening habits than those with less. However, this difference is dramatically balanced by increased arts education, to the degree that college graduates and high school dropouts with extensive arts education demonstrate comparable listening habits.

Closing

Whether a person participates in the arts, and the form and extent of one's participation, depends on a variety of factors. Attempts at explaining these phenomena inevitably yield both information and the need for continuing inquiry. Yet it is reasonable to claim that, overall, arts education contributes to increased arts participation. The broader socialization provided by general education enhances the influence of an arts education, in most cases. However, specific elements of personal background, such as race/ethnicity, gender, and socioeconomic status, appear to affect *which* Americans gain these types of instruction. Having the financial and social resources to support and sustain an arts education is a major influence on who accesses the arts education available in the United States. These influences—some of which are beyond an in-

dividual's power to alter—particularly restrict access to arts instruction within the private, community-based arts education sector. However, it appears that public schools provide arts education to a broader cross section of Americans.

The complexity of the picture of arts participation painted here reflects the elaborate nature of the life experiences that prepare and influence one's participation in the arts. The SPPA92 offers an opportunity to determine broad patterns in Americans' participation in a variety of arts as they relate to patterns of arts/education and sociodemographics.

Assuming this to be valuable, there are certain limitations that need to be kept in mind in interpreting the results of this report. First, the art forms represented in the survey are not necessarily those in which many Americans participate. Second, participating in a particular art form implies a depth of experience that may not necessarily be represented in all responses to individual survey questions. For instance, a respondent may consider "remote control surfing" across television channels and spending a moment or two watching a televised symphony concert as "watching a classical music performance." The commitment of time and attention captured in this instance compromises the definition of "participation" in the arts via video media. An equally important consideration is whether this type of response may be systematically related to a particular subgroup of respondents. However, because one can reasonably assume that this weakness in the validity of the responses is random across the survey sample, there is no reason to question any of the findings related to the sociodemographics of survey respondents. Third, some of the terminology used in the survey to define arts education may be vague. For example, the phrase "lessons or classes in music—either voice training or playing an instrument"—may inadvertently underestimate school-based experiences in classroom music taught by music specialists. This is particularly important for future surveys because since 1962 visual art and general music classes have become the main vehicles for providing music and visual art education in schools (Leonhard, 1991).

Conclusions

Within the limitations of this report, the following conclusions are offered about the impact of arts education on arts participation in the United States:

1. Arts education is the strongest predictor of all types of arts participation, except arts performance. The more arts education a person has, the more extensive one's participation in the arts. Arts education also weakens the

restrictive relationship between socioeconomic status and arts participation, thereby facilitating participation in the arts to a broader cross section of Americans.

2. Arts education has at least twice the power of years of education in predicting arts participation (again with the exception of arts performance). Arts participation is not only a matter of more education, but is an issue of having an arts focus to that education. However, for all relevant types of arts participation, the independent effects of one type of education depends on the amount of the other and varies by type of arts participation. Specifically:

- Overall education has a stronger effect on arts attendance and audio– and video–media-accessed arts participation for persons who also have extensive arts education. The reverse is the case for arts creation.
- Although arts education increases arts attendance and watching the arts via video media, this is significantly more true for people with higher overall education. Arts education promotes arts creation despite the strong detrimental effect of increased overall educational attainment. Breadth of listening to the arts via audio media is most different by education level for individuals with no arts education; however, arts education actually *equalizes* differences in listening habits among individuals of dissimilar educational backgrounds.

3. Gaining an arts education in the United States is a matter of socioeconomic status and gender, with citizens of higher socioeconomic status and women securing higher levels of arts education than their respective counterparts. While men are less educated in the arts than women, their arts participation is comparable, except in the cases of arts creation and print-media involvement.

4. School-based arts education is not related to race or ethnicity, but community-based arts education is differentiated by these characteristics. Also, arts education offered through schools is slightly less related to socioeconomic status than that offered in the private sector. The arts education gained from these agencies positively influences arts participation, though differently by type of arts participation. The largest difference between community- and school-based arts education is with video–media-accessed arts participation, where the former is three times more powerful a predictor than the latter.

5. Factors that influence arts performance and participating in the arts via video media are largely unexplained by the SPPA92. Even arts education, which

has been criticized for possible overemphasis on performance at the expense of knowing something about an art, does not predict arts performance.

6. Increased socioeconomic status directly increases arts participation and also does so indirectly by facilitating access to arts education. Conversely, this has the opposite impact on arts participation for individuals of decreased socioeconomic status.

7. Being more active with leisurely pursuits reduces arts participation of all types except for arts performance and watching the arts via video media, to which leisure activity is not consistently related.

8. There are differences in overall arts education by personal background, with men, African Americans, and Asians generally gaining less arts education than their respective counterparts. These differences are particularly evident when considering arts education that is based in the private sector.

The content and organization of the SPPA92 and the results of this report reflect the complex nature of the life experience that prepares and influences one's arts participation. Determining who in the United States participates in the arts based on sociodemographic and educational background is not a simple task and reflects the complexity of the life experiences that socialize, prepare, introduce, reward, sustain, and extend arts participation.

Further Research

The following suggestions are offered for further research in order to investigate more thoroughly the questions addressed by this report:

1. Early childhood arts experiences. SPPA92 does not contain questions pertaining to early socialization experiences regarding arts education and participation, particularly those provided by parents. Being able to describe and adjust for this is essential in estimating the effects of arts education on arts participation. Not having this information included in the SPPA92 is a change and a loss from earlier SPPAs.

2. Description of the arts education experience. It is commendable that the SPPA92 distinguishes between arts education received in the school and in the community. This certainly represents an improvement over earlier surveys. What is needed now are questions that determine certain basic qualities of those arts education experiences, for example, the number of classes in a particular art form, the duration of the instruction, school status (public, independent, parochial), or the format of the instruction (private or group).

3. Contextual understanding of the status of arts education at all levels of formal schooling. Although information about arts education involvement is valuable, it is insufficient to determine the status of arts education in the United States because nothing is known about the opportunities Americans have in order to learn in the arts. With information about the *context* of arts education, one's understanding of arts education would be improved by being able to view it as relative to the opportunity to learn.

Currently this is impossible because those surveys sponsored by the Department of Education, although they consider the context of student learning, increasingly slight the arts; and because the NEA's Surveys of Public Participation in the Arts, although focused on arts education and participation, do not sufficiently consider elements of educational context that affect the opportunity to learn in the arts, that is, school district investments such as instructional time, faculty/staff, physical space, course requirements, equipment and supplies. It is promising that this issue is touched upon by the arts education research agenda developed by the NEA and the Department of Education (Associations, 1994). At a time when national standards in the arts are being promoted, it is essential to be able to consider the direct and indirect effects on arts achievement and participation of the resources available for systematic arts education, as well as the qualities of the arts education itself.

Appendix A

1992 Survey of Public Participation in the Arts

INTRODUCTION – Now I have some questions about your leisure activities. The Bureau of the Census Is collecting this information for the National Endowment for the Arts. The survey is authorized by Title 20, United States Code, section 954 and Title 13, United States Code, section 8. Your participation in this interview is voluntary and there are no penalties for not answering some or all of the questions. *(If PERSONAL INTERVIEW, hand respondent the Privacy Act Statement, SPPA-13.)*

PGM 3

1. The following questions are about YOUR activities during the LAST 12 months— between _____ 1, 19 ___, and _____ ___, 19 ___.

 With the exception of elementary or high school performances, did YOU go to a live jazz performance during the LAST 12 MONTHS?

 010 0 ☐ No
 Yes – **About how many times did you do this during the LAST 12 MONTHS?**

 ☐☐☐ Number of times

2. (With the exception of elementary or high school performances,) Did you go to a live classical music performance such as symphony, chamber, or choral music during the LAST 12 MONTHS?

 011 0 ☐ No
 Yes – **About how many times did you do this during the LAST 12 MONTHS?**

 ☐☐☐ Number of times

3. (With the exception of elementary or high school performances,) Did you go to a live opera during the LAST 12 MONTHS?

 012 0 ☐ No
 Yes – **About how many times did you do this during the LAST 12 MONTHS?**

 ☐☐☐ Number of times

4. (With the exception of elementary or high school performances,) Did you go to a live musical stage play or an operetta during the LAST 12 MONTHS?

 013 0 ☐ No
 Yes – **About how many times did you do this during the LAST 12 MONTHS?**

 ☐☐☐ Number of times

5. (With the exception of elementary or high school performances,) Did you go to a live performance of a non-musical stage play during the LAST 12 MONTHS?

 014 0 ☐ No
 Yes – **About how many times did you do this during the LAST 12 MONTHS?**

 ☐☐☐ Number of times

6. (With the exception of elementary or high school performances,) Did you go to a live ballet performance during the LAST 12 MONTHS?

 015 0 ☐ No
 Yes – **About how many times did you do this during the LAST 12 MONTHS?**

 ☐☐☐ Number of times

7. (With the exception of elementary or high school performances,) Did you go to a live dance performance other than ballet, such as modern, folk, or tap during the LAST 12 MONTHS?

 016 0 ☐ No
 Yes – **About how many times did you do this during the LAST 12 MONTHS?**

 ☐☐☐ Number of times

8. (During the LAST 12 MONTHS,) Did you visit an ART museum or gallery?

 017 0 ☐ No
 Yes – **About how many times did you do this during the LAST 12 MONTHS?**

 ☐☐☐ Number of times

9. (During the LAST 12 MONTHS,) Did you visit an ART fair or festival, or a CRAFT fair or festival?

 018 0 ☐ No
 Yes – **About how many times did you do this during the LAST 12 MONTHS?**

 ☐☐☐ Number of times

10. (During the LAST 12 MONTHS,) Did you visit an historic park or monument, or tour buildings, or neighborhoods for their historic or design value?

019 ₀☐No

Yes – **About how many times did you do this during the LAST 12 MONTHS?**

☐☐☐ Number of times

11. With the exception of books required for work or school, did you read any books during the LAST 12 MONTHS?

020 ₀☐No

Yes – **About how many books did you read during the LAST 12 MONTHS?**

☐☐☐ Number of books

12. (During the LAST 12 MONTHS,) Did you read any –

Read answer categories

a. Plays? 021 ₁☐No ₂☐Yes

b. Poetry? 022 ₁☐No ₂☐Yes

c. Novels or short stories? 023 ₁☐No ₂☐Yes

13. (During the LAST 12 MONTHS,) Did you listen to –

a. A reading of poetry, either live or recorded? 024 ₁☐No ₂☐Yes

b. A reading of novels or books either live or recorded? 025 ₁☐No ₂☐Yes

14a. (During the LAST 12 MONTHS,) Did you watch a jazz performance on television or a video (VCR) tape?

026 ₁☐No – *Skip to item 14c*
Yes – **Was that on TV, VCR, or both?**
₂☐TV
₃☐VCR
₄☐Both

b. About how many times did you do this in the LAST 12 MONTHS?

027 ☐☐☐ Number of times

c. (During the LAST 12 MONTHS,) Did you listen to jazz on radio?

028 ₁☐No
₂☐Yes

d. (During the LAST 12 MONTHS,) Did you listen to jazz records, tapes, or compact discs?

029 ₁☐No
₂☐Yes

15a. (During the LAST 12 MONTHS,) Did you watch a classical music performance on television or a video (VCR) tape?

030 ₁☐No – *Skip to item 15c*
Yes – **Was that on TV, VCR, or both?**
₂☐TV
₃☐VCR
₄☐Both

b. About how many times did you do this (in the LAST 12 MONTHS)?

031 ☐☐☐ Number of times

c. (During the LAST 12 MONTHS,) Did you listen to classical music on radio?

032 ₁☐No
₂☐Yes

d. (During the LAST 12 MONTHS,) Did you listen to classical music records, tapes or compact discs?

033 ₁☐No
₂☐Yes

16a. (During the LAST 12 MONTHS,) Did you watch an opera on television or a video (VCR) tape?

034 ₁☐No – *Skip to item 16c*
Yes – **Was that on TV, VCR, or both?**
₂☐TV
₃☐VCR
₄☐Both

b. About how many times did you do this (in the LAST 12 MONTHS)?

035 ☐☐☐ Number of times

c. (During the LAST 12 MONTHS,) Did you listen to opera music on radio?

036 ₁☐No
₂☐Yes

d. (During the LAST 12 MONTHS,) Did you listen to opera music records, tapes, or compact discs?

037 ₁☐No
₂☐Yes

17a. With the exception of movies, did you watch a musical stage play or an operetta on television or a video (VCR) tape during the LAST 12 MONTHS?

038 ₁☐No – *Skip to item 17c*
Yes – **Was that on TV, VCR, or both?**
₂☐TV
₃☐VCR
₄☐Both

b. About how many times did you do this (in the LAST 12 MONTHS)?

039 ☐☐☐ Number of times

c. (During the LAST 12 MONTHS,) Did you listen to a musical stage play or an operetta on radio?

040 ₁☐No
₂☐Yes

d. (During the LAST 12 MONTHS,) Did you listen to a musical stage play or an operetta on records, tapes, or compact discs?

041 ₁☐No
₂☐Yes

 FORM SPPA-2 (4-9-92)

18a. With the exception of movies, situation comedies, or TV series, did you watch a non-musical stage play on television or a video (VCR) tape during the LAST 12 MONTHS?

042 — 1 ☐ No – *Skip to item 18c*
Yes – **Was that on TV, VCR, or both?**
2 ☐ TV
3 ☐ VCR
4 ☐ Both

b. About how many times did you do this (in the LAST 12 MONTHS)?

043 — ☐☐☐ Number of times

c. (During the LAST 12 MONTHS,) Did you listen to a radio performance of a non-musical stage play?

044 — 1 ☐ No
2 ☐ Yes

19a. With the exception of music videos, did you watch on television or a video (VCR) tape dance such as ballet, modern, folk, or tap during the LAST 12 MONTHS?

045 — 1 ☐ No – *Skip to item 20a*
Yes – **Was that on TV, VCR, or both?**
2 ☐ TV
3 ☐ VCR
4 ☐ Both

b. About how many times did you do this (in the LAST 12 MONTHS)?

046 — ☐☐☐ Number of times

20a. (During the LAST 12 MONTHS,) Did you watch a program about artists, art works, or art museums on television or a video (VCR) tape?

047 — 1 ☐ No – *Skip to item 21a*
Yes – **Was that on TV, VCR, or both?**
2 ☐ TV
3 ☐ VCR
4 ☐ Both

b. About how many times did you do this (in the LAST 12 MONTHS)?

048 — ☐☐☐ Number of times

21a. I'm going to read a list of events that some people like to attend. If you could go to any of these events as often as you wanted, which ones would you go to MORE OFTEN than you do now? I'll read the list. Go to –

Mark (X) all that apply.

053 — 1 ☐ **Jazz music performances**
✳ 2 ☐ **Classical music performances**
3 ☐ **Operas**
4 ☐ **Musical plays or operettas**
5 ☐ **Non-musical plays**
6 ☐ **Ballet performances**
7 ☐ **Dance performances other than ballet**
8 ☐ **Art museums or galleries**
9 ☐ None of these – *Skip to item 22a*

If only one is chosen, skip to item 22a.
If more than one is chosen, ask –
b. Which of these would you like to do most?

054 — ☐☐ Category number
00 ☐ No one thing most

22a. The following questions are about your participation in other leisure activities.

Approximately how many hours of television do you watch on an average day?

055 — ☐☐ Number of hours

b. During the LAST 12 MONTHS, did YOU go out to the movies?

056 — 1 ☐ No
2 ☐ Yes

c. With the exception of youth sports, did you go to any amateur or professional sports events during the LAST 12 MONTHS?

057 — 1 ☐ No
2 ☐ Yes

d. During the LAST 12 MONTHS, did you go to an amusement or theme park, a carnival, or a similar place of entertainment?

058 — 1 ☐ No
2 ☐ Yes

e. During the LAST 12 MONTHS, did you jog, lift weights, walk, or participate in any other exercise program?

059 — 1 ☐ No
2 ☐ Yes

f. During the LAST 12 MONTHS, did you participate in any sports activity, such as softball, basketball, golf, bowling, skiing, or tennis?

060 — 1 ☐ No
2 ☐ Yes

g. Did you participate in any outdoor activities, such as camping, hiking, or canoeing during the LAST 12 MONTHS?

061 — 1 ☐ No
2 ☐ Yes

h. Did you do volunteer or charity work during the LAST 12 MONTHS?

062 — 1 ☐ No
2 ☐ Yes

i. Did you make repairs or improvements on your own home during the LAST 12 MONTHS?

063 — 1 ☐ No
2 ☐ Yes

j. Did you work with indoor plants or do any gardening for pleasure during the LAST 12 MONTHS?

064 — 1 ☐ No
2 ☐ Yes

23a. (During the LAST 12 MONTHS,) Did you work with pottery, ceramics, jewelry, or do any leatherwork or metalwork?

065 — 1 ☐ No – *Skip to item 24a*
2 ☐ Yes

b. Did you publicly display any of your works?

066 — 1 ☐ No
2 ☐ Yes

24a. (During the LAST 12 MONTHS,) Did you do any weaving, crocheting, quilting, needlepoint, or sewing?

067 ₁☐No – *Skip to item 25a*
 ₂☐Yes

b. Did you publicly display any of your works?

068 ₁☐No
 ₂☐Yes

25a. (During the LAST 12 MONTHS,) Did you make photographs, movies, or video tapes as an artistic activity?

069 ₁☐No – *Skip to item 26a*
 ₂☐Yes

b. Did you publicly display any of your works?

070 ₁☐No
 ₂☐Yes

26a. (During the LAST 12 MONTHS,) Did you do any painting, drawing, sculpture, or printmaking activities?

071 ₁☐No – *Skip to item 27a*
 ₂☐Yes

b. Did you publicly display any of your works?

072 ₁☐No
 ₂☐Yes

27a. With the exception of work or school, did you do any creative writing such as stories, poems, or plays during the LAST 12 MONTHS?

073 ₁☐No – *Skip to item 28a*
 ₂☐Yes

b. Were any of your writings published?

074 ₁☐No
 ₂☐Yes

28a. Did you write or compose any music during the LAST 12 MONTHS?

075 ₁☐No – *Skip to item 29a*
 ₂☐Yes

b. Was your musical composition played in a public performance or rehearsed for a public performance?

076 ₁☐No
 ₂☐Yes

29a. Do you own any original pieces of art, such as paintings, drawings, sculpture, prints, or lithographs?

077 ₁☐No – *Skip to item 30a*
 ₂☐Yes

b. Did you purchase or acquire any of these pieces during the LAST 12 MONTHS?

078 ₁☐No
 ₂☐Yes

30a. During the LAST 12 MONTHS, did you perform or rehearse any jazz music?

079 ₁☐No – *Skip to item 31a*
 ₂☐Yes

30b. Did you play any jazz in a public performance or rehearse for a public performance?

080 ₁☐No
 ₂☐Yes

31a. During the LAST 12 MONTHS, did you play any classical music?

081 ₁☐No – *Skip to item 32a*
 ₂☐Yes

b. Did you play classical music in a public performance or rehearse for a public performance?

082 ₁☐No
 ₂☐Yes

32a. During the LAST 12 MONTHS, did you sing any music from an opera?

083 ₁☐No – *Skip to item 33a*
 ₂☐Yes

b. Did you sing in a public opera performance or rehearse for a public performance?

084 ₁☐No
 ₂☐Yes

33a. During the LAST 12 MONTHS, did you sing music from a musical play or operetta?

085 ₁☐No – *Skip to item 33c*
 ₂☐Yes

b. Did you sing in a public performance of a musical play or operetta or rehearse for a public performance?

086 ₁☐No
 ₂☐Yes

c. During the LAST 12 MONTHS, did you sing in a public performance with a chorale, choir, or glee club or other type of vocal group, or rehearse for a public performance?

087 ₁☐No
 ₂☐Yes

34. (During the LAST 12 MONTHS,) Did you act in a public performance of a non-musical play or rehearse for a public performance?

088 ₁☐No
 ₂☐Yes

35a. (During the LAST 12 MONTHS,) Did you dance any ballet?

089 ₁☐No – *Skip to item 36a*
 ₂☐Yes

b. Did you dance ballet in a public performance or rehearse for a public performance?

090 ₁☐No
 ₂☐Yes

36a. (During the LAST 12 MONTHS,) Did you do any dancing other than ballet such as modern, folk, or tap?

091 ₁☐No – *Skip to item 37a*
 ₂☐Yes

b. Did you dance modern, folk, or tap in a public performance?

092 ₁☐No
 ₂☐Yes

37a. I'm going to read a list of some types of music. As I read the list, tell me which of these types of music you like to listen to?

Mark (X) all that apply.

093
- 1 ☐ **Classical/Chamber music**
- ✳ 2 ☐ **Opera**
- 3 ☐ **Operetta/Broadway musicals/Show tunes**
- 4 ☐ **Jazz**
- 5 ☐ **Reggae (Reg gay')**
- 6 ☐ **Rap music**

094
- 7 ☐ **Soul**
- ✳ 8 ☐ **Blues/Rhythm and blues**
- 9 ☐ **Latin/Spanish/Salsa**

095
- 10 ☐ **Big band**
- ✳ 11 ☐ **Parade/Marching band**
- 12 ☐ **Country-western**

096
- 13 ☐ **Bluegrass**
- ✳ 14 ☐ **Rock**
- 15 ☐ **The music of a particular Ethnic/National tradition**

097
- 16 ☐ **Contemporary folk music**
- ✳ 17 ☐ **Mood/Easy listening**
- 18 ☐ **New age music**

098
- 19 ☐ **Choral/Glee club**
- ✳ 20 ☐ **Hymns/Gospel**
- 21 ☐ **All**
- 22 ☐ **None/Don't like to listen to music** – *Skip to item 38a*

b. *If only one category is marked in 37a, enter code in 37b without asking.* **Which of these do you like best?**

099
☐☐ Category number
- 00 ☐ No one type best

38a. Have you EVER taken lessons or classes in music – either voice training or playing an instrument?

100
- 1 ☐ No – *Skip to item 39a*
- 2 ☐ Yes

b. Did you take these lessons when you were – *Read categories. (Do not read category 4 if respondent is under 25 years old.) Mark (X) all that apply.*

101
- 1 ☐ **Less than 12 years old**
- ✳ 2 ☐ **12–17 years old**
- 3 ☐ **18–24 years old**
- 4 ☐ **25 or older**

CHECK ITEM A
Refer to item 38b
Is box 1 or 2 marked in item 38b?
- ☐ No – *Skip to Check Item B*
- ☐ Yes – *Ask item 38c*

38c. Were these lessons or classes offered by the elementary or high school you were attending or did you take these lessons elsewhere?

102
- 1 ☐ Elementary/high school
- 2 ☐ Elsewhere
- 3 ☐ Both

CHECK ITEM B
Refer to item 38b
If box 4 is marked in item 38b, ASK item 38d.
If not – Is box 2 or 3 marked in item 38b AND the respondent is under 25 years old?
- ☐ No – *Skip to item 39a*
- ☐ Yes – *Ask item 38d*

38d. Did you take any of these lessons or classes in the past year?

103
- 1 ☐ No
- 2 ☐ Yes

39a. (Have you EVER taken lessons or classes) in visual arts such as sculpture, painting, print making, photography, or film making?

104
- 1 ☐ No – *Skip to item 40a*
- 2 ☐ Yes

b. Did you take these lessons when you were – *Read categories. (Do not read category 4 if respondent is under 25 years old.) Mark (X) all that apply.*

105
- 1 ☐ **Less than 12 years old**
- ✳ 2 ☐ **12–17 years old**
- 3 ☐ **18–24 years old**
- 4 ☐ **25 or older**

CHECK ITEM C
Refer to item 39b
Is box 1 or 2 marked in item 39b?
- ☐ No – *Skip to Check Item D*
- ☐ Yes – *Ask item 39c*

39c. Were these lessons or classes offered by the elementary or high school you were attending or did you take these lessons elsewhere?

106
- 1 ☐ Elementary/high school
- 2 ☐ Elsewhere
- 3 ☐ Both

CHECK ITEM D
Refer to item 39b
If box 4 is marked in item 39b, ASK item 39d.
If not – Is box 2 or 3 marked in item 39b AND the respondent is under 25 years old?
- ☐ No – *Skip to item 40a*
- ☐ Yes – *Ask item 39d*

39d. Did you take any of these lessons or classes in the past year?

107
- 1 ☐ No
- 2 ☐ Yes

40a. (Have you EVER taken lessons or classes) in acting or theater?

108
- 1 ☐ No – *Skip to item 41a*
- 2 ☐ Yes

b. Did you take these lessons when you were – *Read categories. (Do not read category 4 if respondent is under 25 years old.) Mark (X) all that apply.*

109
- 1 ☐ **Less than 12 years old**
- ✳ 2 ☐ **12–17 years old**
- 3 ☐ **18–24 years old**
- 4 ☐ **25 or older**

CHECK ITEM E
Refer to item 40b
Is box 1 or 2 marked in item 40b?
- ☐ No – *Skip to Check Item F*
- ☐ Yes – *Ask item 40c*

40c. Were these lessons or classes offered by the elementary or high school you were attending or did you take these lessons elsewhere?

110
- 1 ☐ Elementary/high school
- 2 ☐ Elsewhere
- 3 ☐ Both

CHECK ITEM F

Refer to item 40b

If box 4 is marked in item 40b, ASK item 40d.

If not – Is box 2 or 3 marked in item 40b AND the respondent is under 25 years old?

☐ No – Skip to item 41a
☐ Yes – Ask item 40d

40d. Did you take any of these lessons or classes in the past year?

111 1 ☐ No
2 ☐ Yes

41a. (Have you EVER taken lessons or classes) in ballet?

112 1 ☐ No – Skip to item 42a
2 ☐ Yes

b. Did you take these lessons when you were –
Read categories. (Do not read category 4 if respondent is under 25 years old.)
Mark (X) all that apply.

113 1 ☐ **Less than 12 years old**
✳ 2 ☐ **12–17 years old**
3 ☐ **18–24 years old**
4 ☐ **25 or older**

CHECK ITEM G

Refer to item 41b

Is box 1 or 2 marked in item 41b?

☐ No – Skip to Check Item H
☐ Yes – Ask item 41c

41c. Were these lessons or classes offered by the elementary or high school you were attending or did you take these lessons elsewhere?

114 1 ☐ Elementary/high school
2 ☐ Elsewhere
3 ☐ Both

CHECK ITEM H

Refer to item 41b

If box 4 is marked in item 41b, ASK item 41d.

If not – Is box 2 or 3 marked in item 41b AND the respondent is under 25 years old?

☐ No – Skip to item 42a
☐ Yes – Ask item 41d

41d. Did you take any of these lessons or classes in the past year?

115 1 ☐ No
2 ☐ Yes

42a. (Have you EVER taken lessons or classes) in dance, other than ballet such as modern, folk or tap?

116 1 ☐ No – Skip to item 43a
2 ☐ Yes

b. Did you take these lessons when you were –
Read categories. (Do not read category 4 if respondent is under 25 years old.)
Mark (X) all that apply.

117 1 ☐ **Less than 12 years old**
✳ 2 ☐ **12–17 years old**
3 ☐ **18–24 years old**
4 ☐ **25 or older**

CHECK ITEM I

Refer to item 42b

Is box 1 or 2 marked in item 42b?

☐ No – Skip to Check Item J
☐ Yes – Ask item 42c

42c. Were these lessons or classes offered by the elementary or high school you were attending or did you take these lessons elsewhere?

118 1 ☐ Elementary/high school
2 ☐ Elsewhere
3 ☐ Both

CHECK ITEM J

Refer to item 42b

If box 4 is marked in item 42b, ASK item 42d.

If not – Is box 2 or 3 marked in item 42b AND the respondent is under 25 years old?

☐ No – Skip to item 43a
☐ Yes – Ask item 42d

42d. Did you take any of these lessons or classes in the past year?

119 1 ☐ No
2 ☐ Yes

43a. Have you EVER taken lessons or classes in creative writing?

120 1 ☐ No – Skip to item 44a
2 ☐ Yes

b. Did you take these lessons when you were –
Read categories. (Do not read category 4 if respondent is under 25 years old.)
Mark (X) all that apply.

121 1 ☐ **Less than 12 years old**
✳ 2 ☐ **12–17 years old**
3 ☐ **18–24 years old**
4 ☐ **25 or older**

CHECK ITEM K

Refer to item 43b

Is box 1 or 2 marked in item 43b?

☐ No – Skip to Check Item L
☐ Yes – Ask item 43c

43c. Were these lessons or classes offered by the elementary or high school you were attending or did you take these lessons elsewhere?

122 1 ☐ Elementary/high school
2 ☐ Elsewhere
3 ☐ Both

CHECK ITEM L

Refer to item 43b

If box 4 is marked in item 43b, ASK item 43d.

If not – Is box 2 or 3 marked in item 43b AND the respondent is under 25 years old?

☐ No – Skip to item 44a
☐ Yes – Ask item 43d

43d. Did you take any of these lessons or classes in the past year?

123 1 ☐ No
2 ☐ Yes

44a. (Have you EVER taken a class) in art appreciation or art history?

124 1 ☐ No – Skip to item 45a
2 ☐ Yes

b. Did you take this class when you were –
Read categories. (Do not read category 4 if respondent is under 25 years old.)
Mark (X) all that apply.

125 1 ☐ **Less than 12 years old**
✳ 2 ☐ **12–17 years old**
3 ☐ **18–24 years old**
4 ☐ **25 or older**

CHECK ITEM M — Refer to item 44b

Is box 1 or 2 marked in item 44b?

☐ No – *Skip to Check Item N*
☐ Yes – *Ask item 44c*

44c. Was this class offered by the elementary or high school you were attending or did you take this class elsewhere?

126 — 1 ☐ Elementary/high school
2 ☐ Elsewhere
3 ☐ Both

CHECK ITEM N — Refer to item 44b

If box 4 is marked in item 44b, ASK item 44d.

If not – Is box 2 or 3 marked in item 44b <u>AND</u> the respondent is under 25 years old?

☐ No – *Skip to item 45a*
☐ Yes – *Ask item 44d*

44d. Did you take any of these lessons or classes in the past year?

127 — 1 ☐ No
2 ☐ Yes

45a. (Have you EVER taken a class) in music appreciation?

128 — 1 ☐ No – *Skip to item 46a*
2 ☐ Yes

b. Did you take this class when you were –
Read categories. (Do not read category 4 if respondent is under 25 years old.)
Mark (X) all that apply.

129 — 1 ☐ **Less than 12 years old**
✳ 2 ☐ **12–17 years old**
3 ☐ **18–24 years old**
4 ☐ **25 or older**

CHECK ITEM O — Refer to item 45b

Is box 1 or 2 marked in item 45b?

☐ No – *Skip to Check Item P*
☐ Yes – *Ask item 45c*

45c. Was this class offered by the elementary or high school you were attending or did you take this class elsewhere?

130 — 1 ☐ Elementary/high school
2 ☐ Elsewhere
3 ☐ Both

CHECK ITEM P — Refer to item 45b

If box 4 is marked in item 45b, ASK item 45d.

If not – Is box 2 or 3 marked in item 45b <u>AND</u> the respondent is under 25 years old?

☐ No – *Skip to item 46a*
☐ Yes – *Ask item 45d*

45d. Did you take this class in the past year?

131 — 1 ☐ No
2 ☐ Yes

46a. What is the highest grade (or year) of regular school your FATHER completed?

132 — 01 ☐ 7th grade or less
02 ☐ 8th grade
03 ☐ 9th–11th grades
04 ☐ 12th grade
05 ☐ College (did not complete)
06 ☐ Completed college (4+ years)
07 ☐ Post graduate degree (M.A., Ph.D., M.D., J.D., etc.)
08 ☐ Don't know

b. What is the highest grade (or year) of regular school your MOTHER completed?

133 — 01 ☐ 7th grade or less
02 ☐ 8th grade
03 ☐ 9th–11th grades
04 ☐ 12th grade
05 ☐ College (did not complete)
06 ☐ Completed college (4+ years)
07 ☐ Post graduate degree (M.A., Ph.D., M.D., J.D., etc.)
08 ☐ Don't know

CHECK ITEM Q — Is this the LAST household member to be interviewed?

☐ No – *Go back to the NCS-1 and interview the next eligible NCS household member*
☐ Yes – *END INTERVIEW*

Notes

Appendix B

Adjusting for the Effects of Leisure

TABLE B.1. Changes Due to Adding Leisure Index to the Analyses

Type of Arts Participation	Predictor[1]	Changes in Beta Value		Leisure Index	Changes in R² Values[2]	
		Model I	Model II		Model I	Model II
Attendance	SES	.08***	.07***	−.05***		
	Arts Education	.32***	.31***			
Audio media	Male	.07***	.05***	−.06***	.22***	.23***
	SES	.13***	.12***			
	Arts Education	.42***	.41***			
Video media				.01		
Print media	Male	−.08***	−.09***	−.05***		
	SES	.09***	.08***			
Performance				.02		
Creation	SES	.03*	.02	−.05***		

Note: Model 1: Sociodemographics and Arts Education; Model II: Sociodemographics, Arts Education, and Leisure.
[1] Only those predictors whose beta values changed when LI was included are listed.
[2] Blank cells indicate no change in R² values between models.

*p ≤ .05. **p ≤ .01. ***p ≤ .001.

Appendix C

The Effects of Education on Arts Participation

In preparatory analyses to those of Part 3, the effects of overall educational attainment on arts participation were considered. Findings revealed that an individual's sociodemographic characteristics are strongly related to the amount of education one receives, with the strongest relationship occurring between socioeconomic status and years of education.[51] This result suggests that access to education among adults is very much a matter of socioeconomic status in the United States. Because a person's socioeconomic status in society contributes to access to education, these differences are perpetuated.[52]

Therefore it is important to determine whether socioeconomic status or educational attainment more strongly predicts an individual's participation in the arts. Results suggest that, in general, increased amounts of education positively contribute to an individual's arts involvement for all forms of consumption (Table C.1). However, overall education does not effectively increase one's involvement in performance activities (Table C.2). However, note that although educational attainment has a positive impact on arts participation, the contributing impact of socioeconomic status is not explained away. There is a reasonably strong relationship between SES and participation for every mode of participation except performance and, interestingly, watching the arts on television or video tape. This last finding holds importance in that the impact of education explained away all of the initial relationship between SES and watching the arts.[53]

Education has a purpose which goes beyond being simply a functional transition to work. One does not become educated for the sole purpose of gaining access to employment. Rather, it serves as a socializing force, bringing individuals to the larger cultural milieu and improving their access to, as well as increasing their participation in, art forms which help determine the cultural makeup of our society. In Part 3, this question was pursued further by comparing the role of arts education and the larger socialization context of education on participation in the arts as adults.

TABLE C.1. Arts Consumption by Sociodemographic Background (Model I) and Years of Education After Taking into Account Sociodemographic Background (Model II)

Predictors	Attendance Model I	II	Audio Media Model I	II	Video Media Model I	II	Print Media Model I	II
African American	.02	.02	.12***	.12***	.01	.01	.003	.003
Asian	−.01	−.02	−.01	−.02	.002	−.001	−.04**	−.05***
Hispanic	−.003	.01	.02	.04**	.02	.02	−.05***	−.03**
Male	−.02	−.03*	.01	.01	−.02	−.02	−.13***	−.14***
SES	.18***	.10***	.26***	.14***	.04***	.01	.22***	.10***
Years of Education	—	.20***	—	.29***	—	.09***	—	.28***
R^2	.03***	.06***	.07***	.14***	.01***	.01***	.07***	.13***

*p ≤ .05. **p ≤ .01. ***p ≤ .001.

TABLE C.2. Arts Production by Sociodemographic Background (Model I) and Years of Education After Taking into Account Sociodemographic Background (Model II)

Predictors	Performance Model I	II	Creation Model I	II
African American	−.06***	−.06***	−.05***	−.05***
Asian	.01	.01	.002	.00006
Hispanic	.01	.02	.01	.01
Male	−.01	−.01	−.20***	−.20***
SES	−.003	−.01	.09***	.07***
Years of Education	—	.01	—	.05***
R^2	.01***	.01***	.05***	.05***

*p ≤ .05. **p ≤ .01. ***p ≤ .001.

Appendix D
Technical Information

Path Analysis

Path analysis is an analytic technique that uses ordinary least squares (OLS) regression in progressive stages to build a model of relationships as one influences the next.[54] It is useful when considering analytical models in which not all the predictors of concern are exogenous (external to, or outside, the model); that is, when at least one variable in the model functions as an effect of some predictors and is also a cause of one or more outcomes (Cohen and Cohen, 1983). In these types of models, path analysis uses the endogenous (internal to, or inside, the model) predictors as outcomes of earlier regressions in the model, then estimates the effects of both exogenous and endogenous predictors in later regressions. The final model in the analysis is a full multiple regression estimating the effects of all predictors and confounding factors on the overall outcome.

In each case, the direct effects of exogenous and endogenous predictors on the outcome are given by the standardized partial regression coefficients. The value of using standardized coefficients is that they make it possible to compare the magnitude of partial effects over different dependent measures which may have different units of analysis. The indirect effects of the exogenous variables on the outcome are estimated by the cross products of direct effects through the model. The total effect of any given predictor on the outcome would be the sum of the direct effect and the indirect effects.

The purpose of this technique is to examine relationships which are influenced by intervening factors, by decomposing the total effect into direct and indirect components. This analytic technique is used to estimate the effects of socioeconomic status on arts participation as this access is mediated through differences in arts/education, and to determine how this type of educational experience influences participation as mediated by lifestyle. The investigation explores to what extent these mediating factors contribute to final differences between individuals who did and did not have an education in the arts.

Data Analysis

The final analyses were conducted using the software package, Statistical Program for the Social Sciences (SPSS-x, version 4.1), on a UNIX system. Individuals for whom responses to questions were missing were excluded from the analyses using a pairwise deletion procedure. Results of correlation-based analyses used weighted samples. Parallel regression analyses on unweighted samples were conducted with no differences found.

Notes

1. For information on the rates of arts participation by degree of arts education and of education, see Orend and Keegan (1996). Also, arts education was viewed from a global perspective rather than by individual art form as investigation was made into the possibility of causal relationships between types of arts participation and arts education.

2. Due to the fact that there were so few Native Americans surveyed (N=16), and given the statistical procedures employed in this report, it was necessary to exclude them from the analyses.

3. In the case of listening to music or stage works via audio media, a point was awarded for each art form the respondent listened to via radio broadcast or audio recording. This reflects the content of the SPPA92 questions pertaining to this type of arts participation.

4. For a discussion of race/ethnicity and rates of arts participation by art form, see the NEA Research Division reports by Love and Klipple (1996).

5. Even though arts lessons "in-school" were not limited to those in public schools by the wording of the SPPA92, one can extrapolate a certain degree of nonprivate "publicness" to the SPPA92 questions that distinguish school and community arts instruction, given that approximately 80 percent of American students attended publicly supported schools in 1992 (U.S. Department of Education, 1995).

6. Although the final analytical step took into account various aspect of one's leisurely lifestyle that may compete with participating in the arts for one's time, the inclusion of leisure into the analyses did not increase the ability to predict arts participation, nor did it alter the impact of the other variables on arts participation. For these reasons, mention of leisure in this discussion is limited. See Appendix B for a summary table of the differences between analyses where leisure was included and excluded.

7. This finding does not indicate that a person trained in the arts attends performances four times as much as those who do not, but rather that the relationship between arts education and arts attendance is more reliable and important than ethnic background, SES, or degree of leisure activity.

8. See Reimer (1994) and J. Paul Getty Trust (1985) for discussions of the status of music performance in music education and of the role of visual art production in art education, respectively.

9. In considering the comparative effects of arts education on arts participation by arts education agency (school-based vs. community-based), one should remember that school-based instruction is likely to be delivered to groups of students, while much of what goes on in community-based arts education efforts is within a one-on-one private setting. Consideration of this difference must be made when interpreting the comparative effects of each on arts participation.

10. See Appendix C for a summary of results related to the effects of general education on arts participation.
11. See Arts, Education, and Americans Panel (1977); NEA (1988); Consortium of National Arts Education Associations (1994) [Associations]; National Coalition for Music Education (1991); Fowler (1988); J. Paul Getty Trust (1985).
12. See the SPPA85 monograph by DiMaggio and Ostrower (1992) and DiMaggio and Ostrower (1990) for such analyses and for thoughtful consideration of the implications of differences in arts participation by race and ethnicity.
13. See Love and Klipple (1996) for a description of race/ethnicity and arts participation based on the SPPA92.
14. The interdependence and importance of these two arts education agencies to arts education in America is well defined. See Arts, Education and Americans Panel (1977), National Endowment for the Arts (1988) or Fowler (1988).
15. See for example, Robinson (1993) and DiMaggio and Ostrower (1992.)
16. See the Forward in Robinson (1993) for a description of the purpose of the SPPA, its history, data collection procedures, survey methodology, and an outline of the questionnaire.
17. See Orend (1988) for analyses of data from the 1982 and 1985 SPPA regarding socialization and arts participation.
18. For discussion of arts education and education rates and the degree of arts participation as estimated in the 1992 SPPA, see the companion publication to this monograph by Orend and Keegan (1996).
19. See Orend (1988) for this type of analysis using data from the 1982 SPPA.
20. See Appendix D for a more in-depth description of this statistical protocol and for other technical matters pertaining to this report's analytical techniques.
21. Time points were less than 12 years old, 12–17 years old, 18–24 years old, 25 or older, within the year prior to the survey date.
22. Arts Lesson Duration Scale: an indication of the *duration* of arts lessons over a lifetime. For each art form, a point was awarded for each time period the respondent received arts lessons and then the scores for each type of arts lesson were summed and standardized. Arts Lesson Concentration Scale: standardized mean of the sum of the number of arts for which the respondent received lessons offered in the community and the number of arts for which the respondent received lessons offered in school.
23. Even though the SPPA92 questions about arts lessons in the "school you were attending" did not confine "school" to *public* school, one can extrapolate a certain degree of nonprivate, "publicness" to the responses to those questions, given that approximately 80 percent of Americans attend public schools (U.S Department of Education, 1995).
24. See Gates (1991) for a summary and extension of theories of music participation or Cornwell (1990) for a discussion of arts participation as a dimension of participation in a democracy.
25. This is a reflection of the organization of the questions contained on the 1992 questionnaire and is comparable to a similar analysis of the SPPA 1982 and 1985. See, for example, Orend (1988).

26. See Part 1 for a detailed description of the SPPA92.

27. See Part 1 for a detailed description of the measures of arts education and arts participation used in this report.

28. See the section, "Determining the Effects of Arts Education on Arts Participation," in Part 1 for a description of methodology.

29. The reader is reminded that the effects of arts education on arts participation, as indicated by beta coefficients, are *net* effects; that is, after taking into account the other variables in the model.

30. The reader is reminded that in the current monograph, arts participation is considered globally, across art forms. For a discussion of race and ethnicity and rate of arts participation by art form, see the companion NEA Research Division monograph by Love and Klipple (1996).

31. Compare betas for SES found in Tables 7 with those in Table 5.

32. For discussion of how social differences in access to arts education contribute *indirectly* to differences in participation in the arts as adults, see Chapter 4 of Bergonzi and Smith (1996).

33. The focus here rests on comparing these two effects. Therefore, although a full simultaneous regression was run with each measure, the discussion concerns only the bottom two rows of results in the table. Background variables will be considered in this discussion only when analyses of the effects of school- and community-based arts education produce results that clarify or substantially differ from those of the previous section.

34. This can be attributed in part to the fact that Arts Education Density is an index that also includes information on arts education received as an adult after the age of 17.

35. This discussion is based on analyses of the effects of arts education on arts participation as presented earlier in this section. With one exception, analyses using the variable, Leisure Index (as presented in Part 1) offered no increase in the power of the analytical model to predict arts participation, nor did they substantially alter the relative predictive power (betas) of the other variables. For these reasons, these analyses are not presented in this section, but are summarized in Appendix B. However, limited discussion of the results of these analyses is included in this section's summary, in the Executive Summary, and in Part 4.

36. In addition to arts consumption, higher SES indicated more arts creation, even after adjusting for arts education. However, SES did not impact arts creation after including leisure in the analyses.

37. See Appendix B for a summary of the mostly nonsubstantive changes due to the addition of leisure to the analyses.

38. See Bergonzi and Smith (1996) for a more detailed description of differences in education based on personal background. See Chapter 3 for a description of similar differences in arts education.

39. See Appendix C for a summary of these differences.

40. To help focus the results, years of education have been condensed into logical

categories, namely less than high school degree (2 through 11 years), high school graduate (12 years), some college (13 through 15 years), four years of college (16 years), and more than four years of college (17 through 26). Likewise for degree of arts education but by standard deviation units of the standardized Arts Education Density scale: none (-2 units), very little (-1), average (0), more than average (+1), and a great deal (+2).

41. The reader is reminded that in the current monograph, arts participation is considered globally, across art forms. For a discussion of race/ethnicity and rates of arts participation by art form, see the NEA Research Division monograph by Love and Klipple (1996).

42. Arts education was not significantly related to arts performance either separately (Table 5) or in combination with general education (Table 10). A discussion of the interdependent effects of arts education and education on arts performance is therefore moot.

43. The reader is reminded that "effects" here are *net* effects, that is, after taking into account the other variables in the model.

44. National activity such as the Consortium of National Arts Education Association's submission of arts standards to the U.S. Department of Education that define what every young American should know and be able to do in the arts (Associations, 1994), and the 1997 National Assessment of Educational Progress (NAEP), is slated to be an assessment of the national status of students' achievement in the arts. For evidence that the majority of Americans retain private goals for their children that include having them learn about the arts, see *Americans and the Arts VI* (1992).

45. Given the statistical procedures needed to employ, too few Native Americans were surveyed to be included in these analyses.

46. See Robinson (1993) for such observations using data from the 1992 SPPA.

47. This discussion is based on analyses of the effects of arts education on arts participation adjusting for the competing effects of lifestyle, using the variable, Leisure Index. (Refer to the discussion in Part 1.) With one exception, these analyses offered no increase in the power of the analytical model to predict arts participation, nor did they substantially alter the relative predictive power (betas) of the other variables. For these reasons, tables from these analyses are not presented in this section but are contained in Appendix B. However, some discussion of the results of these analyses is included in this section, in the Executive Summary, and in Part 2.

48. In interpreting these findings one must keep in mind the more individualized nature of community-based arts instruction vs. the group processes employed by school arts teachers.

49. Neither arts education nor education were significant predictors of arts performance. For this reason, arts performance is not included in this discussion.

50. The effect of overall education on print-media involvement was consistent across levels of arts education. Given that reading is an activity that is inherent at all levels of education, one might expect the effect of arts education would be

different for individuals of varying education levels. This was not the case, however. Arts education was more than twice as powerful a predictor of print-media involvement than was overall education.

51. See Chapter 3 in Bergonzi and Smith (1996) for a more detailed description of the effects of overall educational attainment on arts participation.

52. See Spring (1991) for a more elaborate discussion of this topic.

53. The addition of leisure to these preparatory analyses did not alter the results in any substantive way. For this reason, this report does not discuss leisure as a factor in predicting the effects of education on arts participation.

54. A more complete discussion of path analysis can be found in Cohen, J. and P. Cohen (1983), *Applied Multiple Regression/Correlation Analysis for the Behavioral Sciences,* or Pedhauzur, E. J. (1982), *Multiple Regression in Behavioral Research.*

Bibliography

Americans and the Arts VI (1992). New York: Philip Morris Inc.

Arts, Education, and Americans Panel. American Council for the Arts in Education (1977). *Coming to Our Senses: The Significance of the Arts for American Education.* New York: McGraw Hill.

Bergonzi, L.S., and J.B. Smith (1996). *The Effects of Education and Arts Education on Adult Participation in the Arts: An Analysis of the 1992 Survey of Public Participation in the Arts.* Research Contract No. 93–303. Washington, DC: The National Endowment for the Arts, Research Division. To be made available through ERIC in 1996.

Cohen, J., and P. Cohen (1983). *Applied Multiple Regression/Correlation Analysis for the Behavioral Sciences.* Hillsdale, N.J.: Lawrence Erlbaum Associates.

Consortium of National Arts Education Association (1994). *Dance, Music, Theatre, Visual Arts: What Every Young American Should Know and Be Able to Do.* National standards for arts education. Reston, VA: Music Educators National Conference.

Cook, T. D., and D. T. Campbell (1979). *Quasi-Experimentation: Design & Analysis Issues for Field Settings.* Boston: Houghton Mifflin.

Cornwell, T. L. (1990). *Democracy and the Arts: The Role of Participation.* New York: Praeger.

DiMaggio, P., and F. Ostrower (1990). "Participation in the Arts by Black and White Americans." In *The Future of the Arts: Public Policy and Arts Research,* D. B. Pankratz & V. B. Morris, eds. New York: Praeger, 105–140.

———— (1992). *Race, Ethnicity and Participation in the Arts: Patterns of Participation by Hispanics, Whites, and African Americans in Selected Activities, from the 1982 and 1985 Surveys of Public Participation in the Arts.* Research Division Report #25. National Endowment for the Arts.

Fowler, C. (1988). *Can We Rescue the Arts for America's Children? Coming to Our Senses-10 Years Later.* New York: American Council for the Arts.

Gates, J. T. (1991). "Music Participation: Theory, Research, and Policy." *Bulletin of the Council for Research in Music Education,* 109 (Summer, 1991), 1–35.

J. Paul Getty Trust. (1985). *Beyond Creating: The place for Arts in America's Schools.* Los Angeles.

Leonhard, C. (1991). *Status of Arts Education in American Public Schools.* National Arts Education Research Center at the University of Illinois.

Love, J., and B. C. Klipple (1996). *Arts Participation and Race/Ethnicity.* National Endowment for the Arts, Research Division.

National Center for Educational Statistics. (1993). *Schools and Staffing in the United States: A Statistical Profile, 1987–1988.* Washington, DC: Office of Educational Research and Improvement.

National Coalition for Music Education (1991). *Growing Up Complete: The Report of the National Committee on Music Education.* Reston, VA: Music Educators National Conference.

National Endowment for the Arts (1988). *Toward Civilization: A Report on Arts Education.* National Endowment for the Arts.

Orend, R. J. (1988). *Socialization and Participation in the Arts.* Research Division Report #21. National Endowment for the Arts.

Orend, R. J., and C. Keegan (1996). *Education and Arts Participation: A Study of Arts Socialization and Current Arts-Related Activities.* National Endowment for the Arts, Research Division.

Pankratz, D. B. (1987). "Toward Integrate Study of Cultural and Educational Policy." In *Design for Arts in Education,* 89:2, 17.

Pedhauzur, E. J. (1982). *Multiple Regression in Behavioral Research.* New York: Holt, Rhinehart, and Winston.

Reimer, B. (1994). "Is Musical Performance Worth Saving?" *Arts Education Policy Review,* 95(3), 2–13.

Robinson, J. (1993). *Arts Participation in America: 1982–1992*. Research Division Report # 27. National Endowment for the Arts.

U.S. Department of Education, National Center for Educational Statistics (1995). *A Profile of American Seniors in 1992*. NCES No. 95–384, Washington, DC.

About the Authors

Louis Bergonzi, Ph.D., is Assistant Professor of Music Education at the Eastman School of Music of the University of Rochester. He specializes in string education and the sociology of music education, particularly the educational context for school-based arts education programs and the implications of program design on student access to arts/music education programs. He teaches in Eastman's Arts Leadership Program and is President-Elect of the American String Teachers Association.

Julia B. Smith, Ed.D, is Professor of Educational Administration and Evaluation at the Warner School, University of Rochester. She studies the organizational processes of schools and has published articles relating to questions of equity and access to curriculum, particularly concerning issues of gender, racial, and class equity in our schools. In addition, she has studied the satisfaction and self-efficacy of teachers as a function of organizational culture in schools. Her research on arts participation is part of a larger interest in how academic and non-academic goals are articulated and realized for students.

Other Reports on Arts Participation

The most recent nationwide survey of arts participation was conducted in 1992. The following publications report on various aspects of the 1992 Survey of Public Participation in the Arts.

Public Participation in the Arts: 1982 and 1992, Research Division Note #50. A 10-page summary comparing the results of the 1982 and 1992 surveys.

Arts Participation in America: 1982-1992, Research Division Report #27. A more detailed discussion (100 pp) of the 1982 and 1992 surveys.

Research Division Notes #51, #52, and #55 provide brief summaries of data on demographic information for the live broadcast and recorded media audiences and on regional and metropolitan audiences. Division notes and Report #27 are available from The Research Division, National Endowment for the Arts, 1100 Pennsylvania Avenue NW, Washington, DC 20506.

The Research Division of the Arts Endowment has been studying trends in the size and characteristics of arts audiences for two decades. A complete description of the Division's work in this area through the most recent nationwide study, Survey of Public Participation in the Arts, 1992, is contained in *A Practical Guide to Arts Participation Research*, Research Division Report #30. This report is available through the National Assembly of Local Arts Agencies, 927 15th Street NW, 12th Floor, Washington, DC 20005, (202) 371-2830.

The Division has also funded fifteen monographs that analyzed various aspects of the results of the 1992 and 1982 surveys. Each of these documents, which are listed below, are being deposited in the Educational Research Information Center (ERIC) system to facilitate distribution.

Age Factors in Arts Participation, Richard A. Peterson and Darren E. Sherkat

American Dance 1992: Who's Watching? Who's Dancing? Jack Lemon/Jack Faucett Associates

American Participation in Opera and Musical Theater, 1992, Joni Maya Cherbo and Monnie Peters

American Participation in Theater, Chris Shrum/AMS Planning and Research Corp.

Americans' Personal Participation in the Arts, Monnie Peters and Joni Maya Cherbo

Arts Participation and Race/Ethnicity, Jeffrey Love and Bramble C. Klipple

Arts Participation by the Baby Boomers, Judith Huggins Balfe and Rolf Meyersohn

Cross-Over Patterns in Arts Participation, Richard J. Orend and Carol Keegan

Education and Arts Participation: A Study of Arts Socialization and Current Arts-Related Activities, Richard J. Orend and Carol Keegan

The Effects of Education and Arts Education on Adult Participation in the Arts: An Analysis of the 1992 Survey of Public Participation in the Arts, Louis Bergonzi and Julia Smith

Hold the Funeral March: The State of Classical Music Appreciation in the U.S., Nicholas Zill

Jazz in America: Who's Listening? Scott DeVeaux

Patterns of Multiple Arts Participation, Jeffrey Love

Reading in the 1990s: Turning a Page or Closing the Books? Nicholas Zill

Tuning In and Turning On: Public Participation in the Arts via Media in the United States, Charles M. Gray

Seven of these have been condensed and published by Seven Locks Press as the following:

Research Division Report #31: *Jazz in America: Who's Listening?* Scott DeVeaux

Research Division Report #32: *American Participation in Opera and Musical Theater, 1992*, Joni Maya Cherbo and Monnie Peters

Research Division Report #33: *Turning On and Tuning In: Media Participation in the Arts*, Charles M. Gray

Research Division Report #34: *Age and Arts Participation with a Focus on the Baby Boom Cohort*, Richard A. Peterson, Darren E. Sherkat, Judith Huggins Balfe, and Rolf Meyersohn

Research Division Report #35: *American Participation in Theater*, AMS Planning & Research Corp.

Research Division Report #36: *Effects of Arts Education on Participation in the Arts*, Louis Bergonzi and Julia Smith